IMAGES
of America

SILVERADO
CANYON

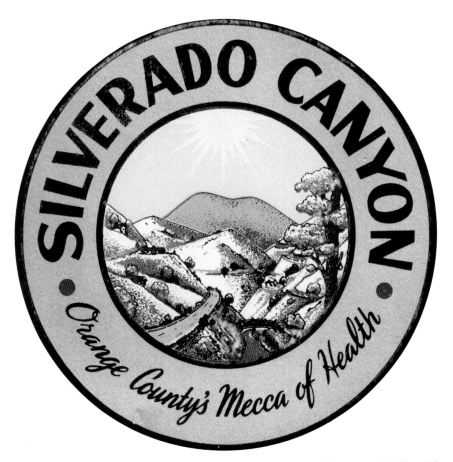

This emblem was created in the 1950s as a promotional item by Florence Lobdell, a Silverado resident and realtor. (Courtesy of Judy Myers.)

ON THE COVER: Taken in 1908 at the Holtz Ranch, this image captures two young couples enjoying a Sunday buggy ride. Prominently displayed in the image are two large flower stalks of yucca whipplei, commonly called Our Lord's Candle, a familiar early-spring sight in the canyon. The couple on the left is Laura Huntington and Lester Slaback, who would later marry and settle in Silverado. The couple on the right is unidentified. (Courtesy of the Silverado Public Library.)

IMAGES
of America

SILVERADO
CANYON

Susan Deering

ARCADIA
PUBLISHING

Published by Arcadia Publishing
Charleston SC, Chicago IL, Portsmouth NH, San Francisco CA

Printed in the United States of America

Library of Congress Catalog Card Number: 2008928803

For all general information contact Arcadia Publishing at:
Telephone 843-853-2070
Fax 843-853-0044
E-mail sales@arcadiapublishing.com
For customer service and orders:
Toll-Free 1-888-313-2665

Visit us on the Internet at www.arcadiapublishing.com

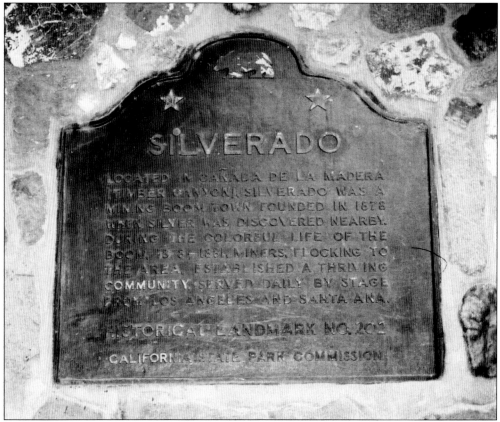

Silverado has been designated California Historical Landmark No. 202 by the California State Park Commission. (Courtesy of the author's collection.)

CONTENTS

ACKNOWLEDGMENTS

First and foremost, I must thank Lucille Cruz at the Silverado branch of the Orange County Public Library for declining and then presenting me with the opportunity to write this book. In addition to providing me with both historical and moral support, she allowed me access to many of the historical photographs herewith.

I thank Harvey and Helen Shaw for welcoming me into their home and for sharing wonderful photographs, stories, lunches, and laughs. Speaking to Jim Sleeper was an honor, and I thank him for his contribution at the beginning of this project. I found a true treasure in Bob Blankman at First American Corporation, who always helped and listened with a smile. Thanks also to Lecil and Neva Slaback and to Jerry Keane of Keane Photography. Thanks to Lizeth Ramirez at the Orange Public Library, to Jane Newell at the Anaheim Public Library, and to Jennifer Ring at the Bowers Museum.

Silverado is a special place, and if it were not for the local support given to me, I may never have finished this project. Special thanks go to my mother, Carole Deering; Wendy Esteras; Ruth Loc; Judy Myers; Gary Wamsley; Brett and Chay Peterson; Greg Petersen; Jean Hobson Farr; Fran Ayers; Bev Mileham; Jane Bove; Steve Kerrigan of the Silverado Volunteer Fire Department; and to the Inter-Canyon League. Finally, I thank my sweet, beloved Larry Gilstrap for his continued love and support throughout this endeavor.

—Susan Deering

INTRODUCTION

Nestled in the Santa Ana Mountains below Santiago Peak, in what is now the Cleveland National Forest, is situated a rural community steeped in history called Silverado. Surrounded by steep canyon walls filled with live oak and sycamore trees, Silverado is home to the mountain lion, coyote, and deer, and was once home to the now extinct grizzly bear. With an elevation that ranges from 1,100 to 1,800 feet, Silverado has always been smog and fog free. First inhabited by the Tongva (now Gabrielino) and Acjachemen (now Juaneno) Indian tribes, Silverado Canyon proved to be an excellent location for hunting and acorn harvesting, and as a reliable nearly year-round water source.

When members of the Portola expedition arrived in 1769, the Native American lifestyle was disrupted. Soon the Native Americans were being converted to Christianity and assisting in the construction of Mission San Juan Capistrano. Timber from upper Silverado Canyon was transported to the mission and was used in the construction of the structure. Black Star Canyon played host to the only documented Native American massacre in Orange County, which occurred in 1832. Evidence of Native American habitation exists today in both Silverado and Black Star Canyons.

The first permanent resident arrived and settled sometime in the 1850s. Shortly thereafter, others arrived and homesteaded in Silverado, tending to fruit trees and bees. In 1877, while hunting in the upper canyon, Hank Smith and William Curry of Santa Ana discovered a piece of blue-white quartz embedded with silver. Assayed and valued at approximately $60 per ton, Smith and Curry staked a claim and the silver rush was on, turning the quiet canyon into a bustling mining town. Hundreds of men arrived in search of newfound fortune.

The sleepy area previously known as Canon de la Madera (Timber Canyon) by the Spaniards was renamed Silverado City, eventually shortened to Silverado. By 1878, Silverado was established with a post office, hotels, stores, and saloons. Two daily stages ran to Los Angeles and three to Santa Ana. At the height of activity, the population possibly reached 1,500. The most successful discovery was made by Deputy John D. Dunlap, who arrived in town with a warrant to serve. Deputy Dunlap never located his fugitive, instead locating what became the best known and most successful of all the silver mines. Coal was also discovered during this time at the mouth of the canyon. Eventually, a town site named Carbondale was established with its own post office, hotels, stores, and saloons. The excitement did not last long. In 1883, after disappointing results of both the silver and coal discoveries, only 16 people were listed as residents of the canyon, and Carbondale was absorbed into Silverado. Today both the original sites of Silverado and Carbondale are California Historical Landmarks.

By 1887, Silverado had returned to its original calm, quiet atmosphere with homesteading families hard at work tending their properties. Newcomers began arriving, attracted by the possibility of a peaceful and productive life. In 1889, the canyon area was surveyed by the U.S. government. Only those families actually settled on their claims could retain them, with the remaining land becoming a forest preserve. In 1908, that forest preserve became known as the Cleveland National Forest.

In 1895, Silverado was first promoted as a health resort. A natural sulfur spring was discovered on a piece of property belonging to Charles Mason. Mason was an entrepreneurial gentleman who seized the opportunity to turn this property into Mason's Chateau—A Health Resort. Placing an advertisement in the *Blade*, a nearby newspaper of some repute, he cultivated a clientele looking for a place to "take the waters." Silverado was soon gaining fame as a resort, being referred to in publications as "Orange County's Only Mountain Resort."

During the 1920s and 1930s, developers arrived and began turning abandoned mining cabins into small bungalows. Creative Hollywood types discovered a place to shoot films and get away for the weekend. Long Beach residents also came to enjoy the offerings of the canyon. Tracts were formed and sold under appealing names such as Albula and Miller Manor. In 1935, a rediscovered sulfur spring boosted the status of the canyon with the announcement of the construction of a new and larger bathhouse, complete with an outdoor plunge. Silverado became an established year-round community with a school, restaurants, hotels, stores, dance halls, a barber, and a library (albeit located in the post office).

As the community grew, a local volunteer fire department was established that continues to operate today. Eventually, the appeal of "taking the waters" faded. Eating and drinking establishments either went up in flames or were turned into residences, and once again, Silverado was transformed into a quiet, sleepy, forgotten community—until February 1969, when 18 inches of rain fell in 72 hours. Massive flooding occurred, destroying and damaging homes, and the Silverado Fire Station was destroyed by a landslide, killing five inside. So powerful were the landslide and flooding that the helmet of the fire chief was washed from its place inside the station and was not found until almost 20 years later miles down the canyon. As is typical of canyon residents, the community united and began cleaning up and rebuilding. A new fire station was built, and those who perished are remembered on a memorial plaque that is prominently displayed out front.

Today Silverado Canyon continues to attract those interested in a quieter, slower-paced lifestyle where neighbors know one another and the opportunity for involvement is as much or as little as one desires. Currently, Silverado has an estimated population of 3,000 living in approximately 1,200 dwellings. A community with no sidewalks, few streetlights, and a speed limit of 25 miles per hour recalls a time since past. The Silverado Post Office remains the only option for mail delivery for the majority of residents, and the Canyon Market and the Silverado Library are the places to go for breaking news. Silverado is a place where residents coexist with the coyote and rattlesnake, and Mother Nature provides natural air-conditioning under the canopy of a live oak or sycamore tree. An afternoon stroll can be a hike into the Cleveland National Forest just outside your door. Birds chirp and frogs croak and the trickle (or roar) of the creek can be heard right outside windows. Stars are visible at night, and it is so quiet one can actually hear them twinkle. Silverado remains a unique and charming part of Orange County.

One

EARLY SETTLERS

Before Europeans arrived in Silverado, the canyon was home to Native Americans belonging to the Shoshonean linguistic group, now known as the Tongva (or Gabrielino) and Acjachemen (or Juaneno) Indian tribes. Living peacefully off the land, theirs was an idyllic existence. With a plentiful supply of natural resources, the men hunted rabbits and birds, while the women harvested acorns, which grew in great abundance. The Spaniards arrived in 1769 and brought the message of Christianity with them. They established the California missions, and the Native Americans assisted in the construction of Mission San Juan Capistrano. Timbers were hauled from the upper canyon to San Juan Capistrano and were used as joists in the structure. Eventually, the Native Americans were relocated to the missions, and the canyon was left uninhabited.

The first white residents of the canyon were Samuel and Betty Shrewsbury, who arrived in 1876. They cured limestone, raised goats, and made honey. The 1880s in Silverado were a time for pioneers. Hardy souls and those with a sense of adventure and ambition were attracted to the canyon. Most settlers were of European descent and had come west looking toward a future of promise and prosperity. Some of those who arrived then were the Alsbachs, the Shaws, and the Masons. Attracted by the climate, they brought their families, claimed property, and began cultivating the land. The ranches harvested walnuts, apricots, and peaches, constructed apiaries, cured limestone, and raised goats and sheep.

The early settlers established home sites that still exist today.

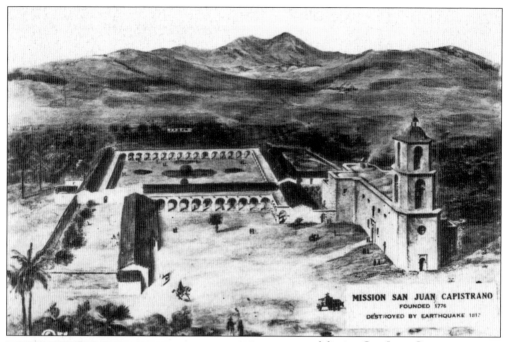

MISSION SAN JUAN CAPISTRANO
FOUNDED 1776
DESTROYED BY EARTHQUAKE 1812

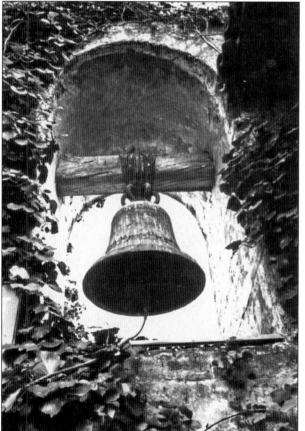

Mission San Juan Capistrano, the seventh of the California missions, was established in 1775 by Fr. Fermin Lausen. Shortly after his arrival, Father Lausen returned to San Diego, leaving the mission vacant. Fr. Junipero Serra arrived in 1776 and reestablished the mission. The local Native Americans, now known as the Juanenos and Gabrielinos, helped construct the mission buildings and church using timber from upper Silverado Canyon. (Courtesy of First American Corporation.)

In 1791, the bell tower at Mission San Juan Capistrano was completed. This image of the low campanario from the early 1900s illustrates the wonderful usage of timber that was hauled from the upper Silverado Canyon by the Native Americans and used at the mission. (Courtesy of First American Corporation.)

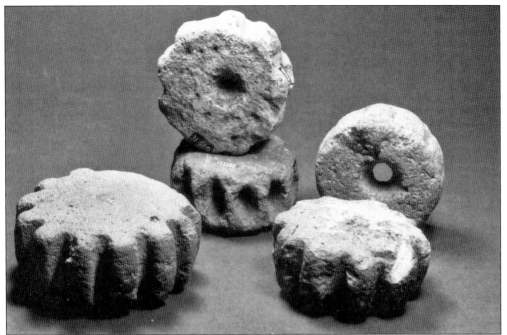

The cog stones in this image were recovered from Silverado Canyon. Cog stones are unique artifacts that date from 6000–3500 BC and have only been found in Southern California. Cog stones range in size from 1.5 to 6 inches in diameter and generally resemble a donut. Researchers still debate the meaning of cog stones, agreeing only that they may have been used in ceremonial rites. (Courtesy of the Bowers Museum.)

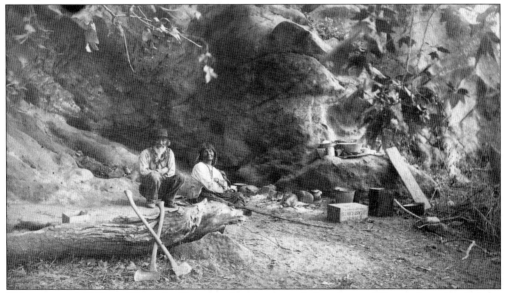

Taken around 1900 in Silverado Canyon, this photograph depicts two Native Americans, most likely a husband and wife from the Juaneno tribe, at an established cooking site surrounded by tools and supplies. In 1835, the California mission system was dismantled and secularized, and the Native American residents were free to leave. Some returned to the canyon and reestablished home sites. (Courtesy of the Local History Collection, Orange Public Library, Orange, California.)

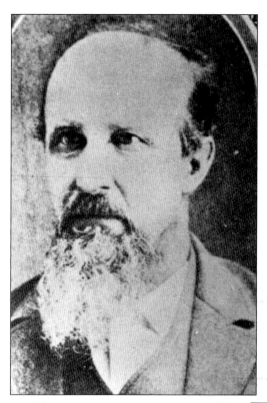

Samuel Shrewsbury was the first white resident of the canyon, settling in the main canyon in 1876. He was the first to establish a lime kiln and bring bees to the canyon, and his property was well known for its fruit and nut trees. In 1877, Los Angeles County officials elected him Silverado justice of the peace. (Courtesy of the Silverado Public Library.)

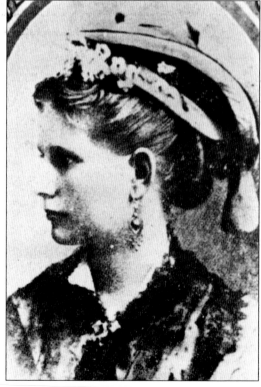

Betty Shrewsbury, wife of Samuel Shrewsbury, adapted well to her pioneer life in the canyon. Reported to have a courageous spirit, she was an attentive homemaker and the mother of two sons, Walter and Lewis. Her family lived comfortably in a house that included a rare convenience: water piped from the spring to the kitchen. (Courtesy of the Silverado Public Library.)

In 1892, Mabry Alsbach, then a resident of Downey, delivered a calf to Silverado Canyon. Deciding the canyon climate was more desirable for his wife and family, he later traded a sow and her piglets for a land claim. Barter was a common and accepted form of exchange. This claim allowed him the right to homestead. (Courtesy of the Silverado Public Library.)

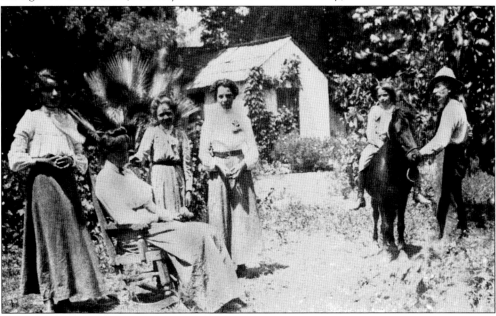

This image, taken in 1903, shows the Alsbach family on their homesteaded property. Two 80-acre sites that formed an L-shape were chosen by Mabry Alsbach, and he, his wife, Mary, and their four daughters settled on the property. The family members are, from left to right, Ruth, Mary (seated), Elizabeth, Naomi, Ruby (on horseback), and Mabry. (Courtesy of the Silverado Public Library.)

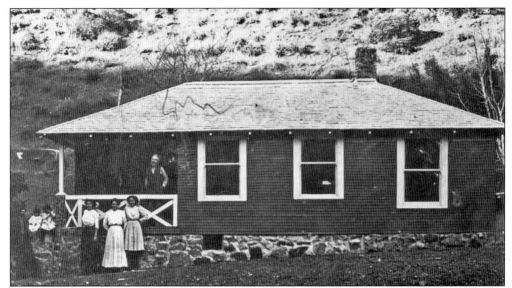

In the early 1900s, when most mining activity had died down, a few miners remained at the end of the canyon. Mabry Alsbach developed a barter system with the remaining miners and traded perishable items raised on his property for excess building materials left behind. The ranch house in this image was constructed using abandoned or no longer needed mining materials and was completed by 1908, when this photograph was taken. (Courtesy of the Silverado Public Library.)

An aerial view of the Alsbach property was taken in 1911. Eighty acres of the 160-acre Alsbach homestead was surrounded by steep canyon walls near a stream, with the other 80 acres located 1,000 feet higher. Both locations proved more than satisfactory for dry-land farming. Mabry Alsbach raised corn, wheat, apricots, peaches, and walnuts. His stock included dairy cows, pigs, turkeys, chickens, and horses. (Courtesy of the Silverado Public Library.)

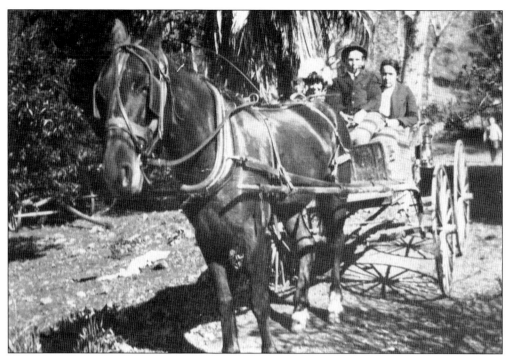

Occasionally a buggy ride was in order. A trip to El Modena, the nearest town in 1905, when this photograph was taken, to procure supplies and run errands was an all-day affair. This image depicts Elizabeth and Ruby Alsbach being driven to town by neighbor Bobby Shaw. (Courtesy of the Silverado Public Library.)

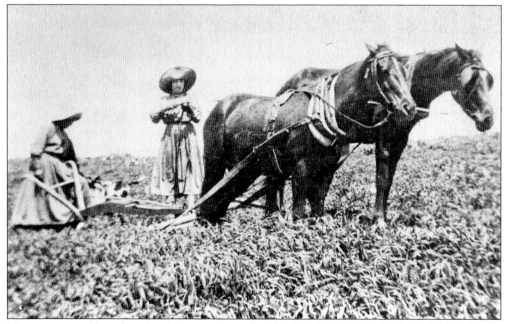

Managing a ranch and tending the crops was a family affair. Daughters Elizabeth (left) and Ruby Alsbach are shown here in 1912 plowing the fields of the "upper 80" acres of the Alsbach family ranch with their trusty horses Bob and Kit. (Courtesy of the Silverado Public Library.)

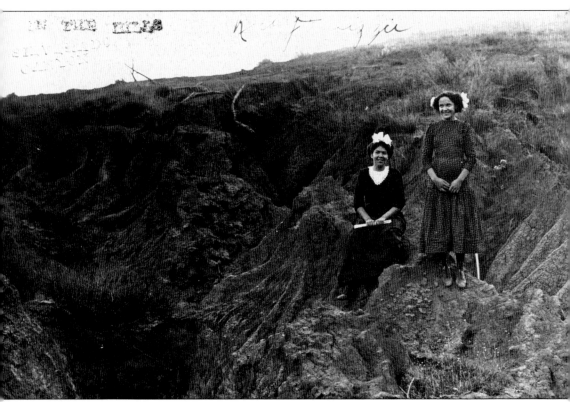

Sisters Elizabeth (left) and Ruby Alsbach often spent their free time exploring the area around their home. Here they were accompanied by their uncle Scott Lucas, a photography enthusiast who lived with the family on the ranch. This image, taken in 1912 and turned into a postcard, depicts not only the attire of the period, but also the innocent enthusiasm of two young ladies enjoying nature. Rarely did a lady wear something other than a dress for any occasion, even hiking. It is in this area in lower Silverado Canyon, often referred to as "the Silverado sinks," that bones and fossils have been discovered. During the Miocene period, between 2 million and 20 million years ago, the Santa Ana Mountains, of which Silverado Canyon is a part, were covered by a sea. Evidence remains of this ancient time. Marine fossils are still uncovered in this part of the canyon. (Courtesy of Harvey and Helen Shaw.)

In 1916, the Alsbach family had a well-established and successful ranch. The three oldest daughters—Ruth, Naomi, and Elizabeth—had married and were living away from the ranch. Visiting the Alsbach ranch in 1916 are, from left to right, Naomi (Alsbach) Schulz, Ray Mauerhan, Elizabeth (Alsbach) Shaw, Ruth (Alsbach) Mauerhan, her boyfriend holding Tommy Shaw, Lily Drury and her husband (seated), Mary Alsbach, Ruby Drury, Dorothy Mauerhan, Ruby Alsbach, and Mabry Alsbach. (Courtesy of the Silverado Public Library.)

An afternoon gathering at the Alsbach family ranch allowed the ladies to don their finest attire. Modeling the fashions of the day in 1916 are the Alsbach sisters, seen here from left to right: Ruby Alsbach, Elizabeth Shaw, Ruth Mauerhan, and Naomi Schulz. (Courtesy of Harvey and Helen Shaw.)

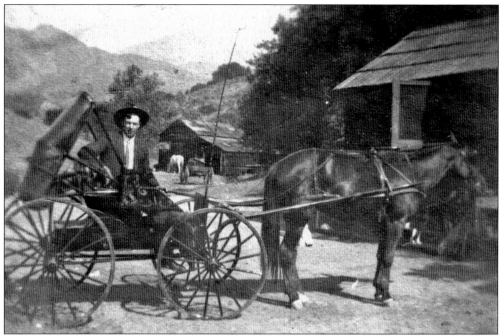

Neighboring families exchanged not only goods with one another, but also manpower. When more manpower was needed than could be provided by a family on its own, neighbors traveled to nearby farms and ranches to help with the crops. This image from 1913 depicts Silverado neighbor Asbury Shaw preparing to depart his ranch with a horse and buggy. (Courtesy of Harvey and Helen Shaw.)

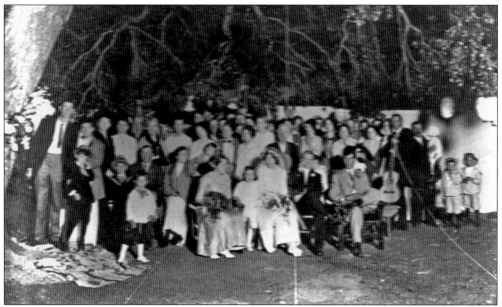

The wedding of Elizabeth Alsbach and Frank Shaw on June 16, 1913, was held at the Alsbach ranch house. The marriage legally united two well-established canyon families, the Alsbachs and the Shaws. This image depicts the bridal party surrounded by friends, family, and musicians posing under the canopy of a mature oak tree. (Courtesy of Harvey and Helen Shaw.)

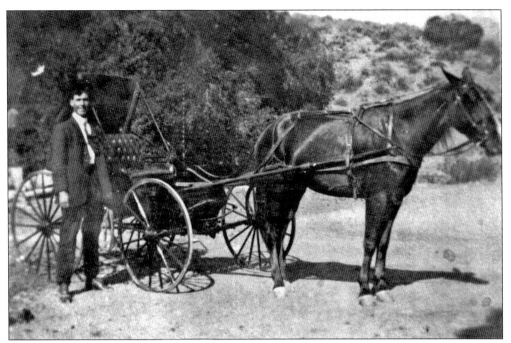

Asbury Shaw, depicted here in 1915, served as best man at his brother Frank's wedding to Elizabeth Shaw in 1913. While there, he met Ruby Alsbach, sister of the bride and maid of honor. This photograph, taken in December 1915, depicts a prosperous and handsome young man and was sent to Ruby Alsbach as a Christmas note. Inscribed on reverse is "Merry XMAS, 1915." (Courtesy of Harvey and Helen Shaw.)

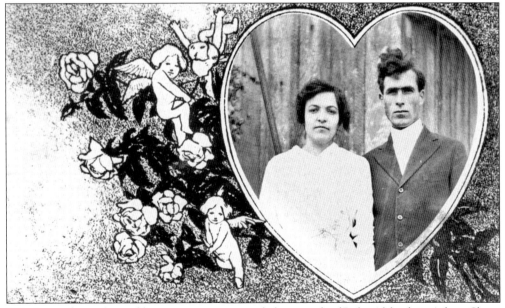

This image shows the wedding announcement and photograph of Ruby Alsbach to Asbury Shaw. Married in October 1916, they established a home site for themselves not far from the Alsbach family ranch and thus added to property holdings of both the Shaw and Alsbach families. (Courtesy of the Silverado Public Library.)

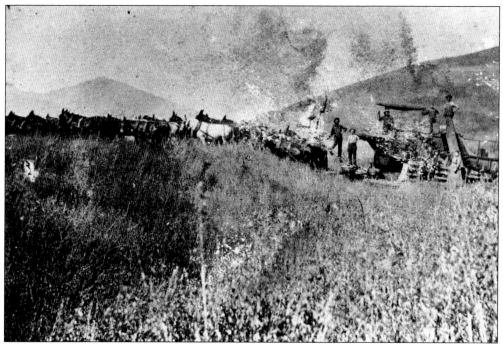

This is the harvest of wheat on the Silverado Canyon property of Asbury Shaw around 1920. The process began with a horse-drawn binder that would cut the wheat stalks and gather them into bundles. The bundles would then be stacked into windrows to dry. Eventually, a threshing machine would be utilized to finish the process. (Courtesy of Harvey and Helen Shaw.)

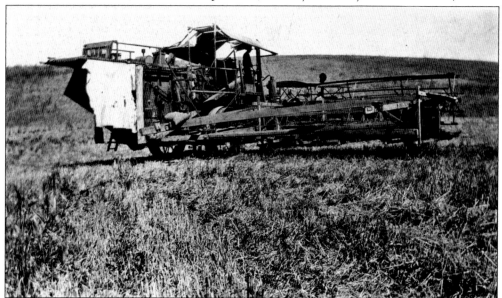

Beginning in the 1920s, gasoline-powered machines began replacing horse-drawn machines for use in the cultivation of crops. Asbury Shaw was the proud owner of a gasoline-powered threshing machine, which he used to harvest wheat. A threshing machine is used for separating the wheat kernels from the straw stalks. He is seen here operating his threshing machine on his Silverado Canyon property around 1920. (Courtesy of Harvey and Helen Shaw.)

This image shows the home of Clara Mason around 1895. The Mason family first purchased property in Silverado in 1887 in the area formerly known as Carbondale and expanded their holdings by purchasing additional canyon property throughout the years. Mason lived here while she taught at the school in Silverado from 1891 until 1895. She stands on the porch with an unidentified child in the front yard. The home burned in 1914 or 1915. (Courtesy of Harvey and Helen Shaw.)

Here is another angle of the home of Clara Mason. Situated among mature oaks and sycamores, the setting was inviting and typical of the property purchased by the Masons. With wraparound porches and on large parcels of land, the Masons built their structures to accommodate more than just one family, making them available to visiting mining businessmen and campers alike. The Mason family established the first health resort. (Courtesy of Harvey and Helen Shaw.)

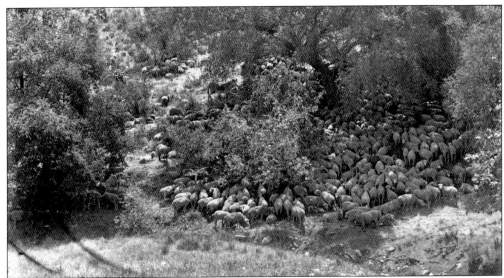

Herds of sheep were common sights in the early 1900s in the Santa Ana Mountains. Often herds were taken into Silverado Canyon to graze. This photograph was taken in 1906 by visiting Adolph Dittmer of Orange, California. Visible is a herd of sheep on a Silverado hillside surrounded by native chaparral and California live oaks. Barely visible in the center of the photograph is the horse belonging to the shepherd. (Courtesy of the Local History Collection, Orange Public Library, Orange, California.)

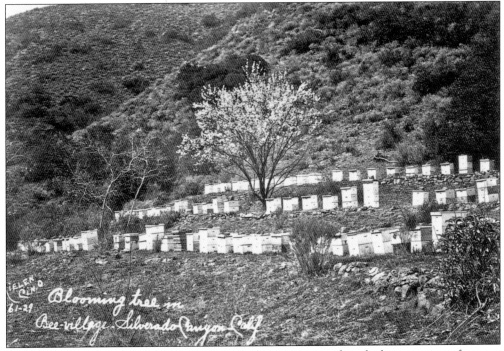

Beekeeping has taken place in Silverado since the late 1860s, providing the largest source of income for many years to those living in the canyon. The biggest hazard then to a beekeeper was the grizzly bear, the last of which was killed in Holy Jim Canyon in 1908. This photograph was taken in the early 1900s of a bee village in Silverado Canyon. (Courtesy of First American Corporation.)

Two

HOLTZ RANCH

Initial contact with the canyon and what is known as the Holtz Ranch was first made by the native people, who used the site for seasonal hunting and gathering. Evidence remains of their presence in arrowheads and cog stones found on the property and in morteros (grinding holes) still in situ. Francisco Soto was the first permanent resident of Silverado Canyon. He settled on this property in the 1850s and built himself a home of adobe brick. He never filed a legal claim and eventually lost the property.

In 1892, Thomas Hughes became the owner of the property. Employed by the Southern Pacific Railroad, who had recently reassessed the land to its advantage, Hughes and his family settled into the adobe structure. In 1894, Joseph Holtz, a native of France, came to Silverado Canyon and became interested in the raising of bees. In 1901, after spending many summers learning the bee culture, Joseph Holtz purchased 320 acres, known as a half-section of land, which included the former Soto/Hughes home. Joseph Holtz married Mary Veigh of Orange in 1905, and the union eventually produced seven children. The Holtzes became farmers of wheat, barley, alfalfa, English walnuts, and a variety of fruit trees. The Holtz Ranch had the first dairy and creamery in the canyon, and local deliveries were made by bicycle. In 1920, the 160 bee colonies belonging to Joseph Holtz yielded 13 tons of honey.

In 1902, Joseph Holtz sold a one-acre parcel of the ranch to the Orange School District for $50 in gold. The Silverado School was established with the help of Holtz, who assisted with the construction of the one-room structure. The Silverado School continued to operate on the property until 1957, when a new structure was constructed on Santiago Canyon Road.

The Holtz Ranch remained in the family until it was sold in 1999.

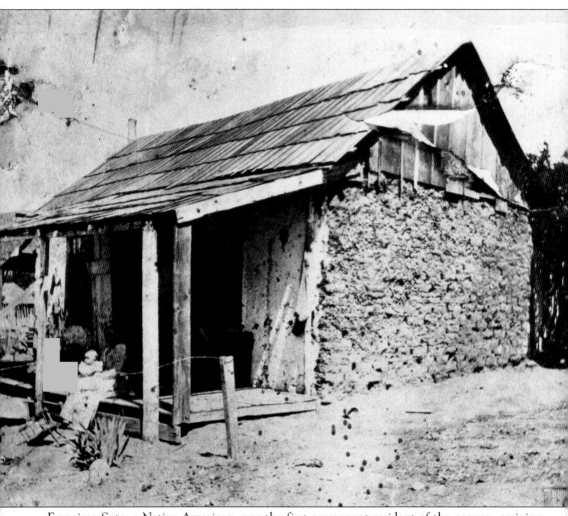

Francisco Soto, a Native American, was the first permanent resident of the canyon, arriving sometime in the 1850s. He established a home site and, knowing no law save that of possession, never filed a legal claim. He built himself a home of adobe brick that was situated at some elevation, ensuring warmth in winter and a cool space in summer. In 1892, the Southern Pacific Railroad resurveyed the property and removed Francisco Soto, claiming the Soto home site belonged to them. Thomas Hughes, a foreman with the Southern Pacific Railroad, and his family then became the legal residents of the property. He and his wife, Elizabeth, along with their son, pictured here, settled into the adobe structure built by Soto. Visible here is an added wooden porch and roof attached to an original wall of exposed adobe brick. In 1901, this was the only structure standing on the property when it was purchased by Joseph Holtz and renamed the Holtz Ranch. (Courtesy of the Bowers Museum.)

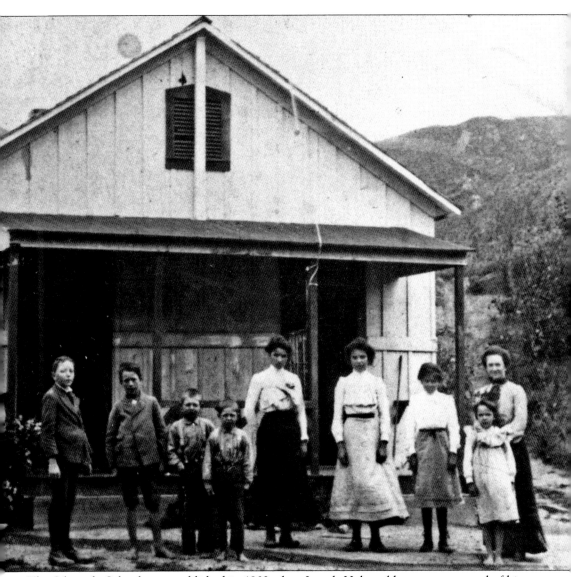

The Silverado School was established in 1903 when Joseph Holtz sold a one-acre parcel of his ranch property to the Orange School District for $50 in gold. A one-room wooden schoolhouse was built with a wood-burning stove in the corner, with a bucket of drinking water with a dipper was kept on a shelf in the entryway. Outhouses were situated behind the schoolhouse, one for boys and one for girls. The school day began after the teacher made a fire in the stove. At noon, a sack lunch was eaten and games were played. In the afternoon, the students cleaned the blackboards and the teacher swept the floor. School teachers were usually young, unmarried women from outside the canyon who boarded at either the Holtz Ranch or with the Alsbach family. Pictured here in 1903 are, from left to right, C. Edinger, A. Hughes, Willie Shaw, Rob Shaw, Naomi Alsbach, Ruth Alsbach, Mary Elizabeth Alsbach, Ruby Alsbach, and an unidentified teacher. (Courtesy of the Silverado Public Library.)

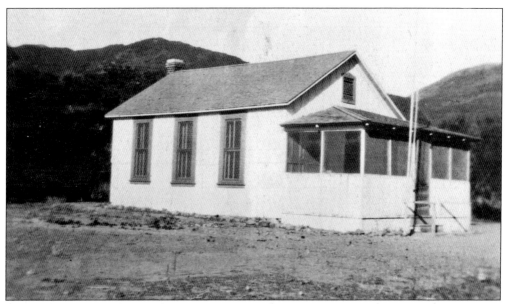

In the early years, the Silverado School had a student population of between 8 and 15 students. School closed for the winter on account of the rain, which caused a high water level in the creek and poor creek crossings. Over the years, the Silverado schoolhouse was upgraded and improved upon. This image, dated around 1919, shows an added enclosed porch and upgraded chimney. (Courtesy of the Silverado Public Library.)

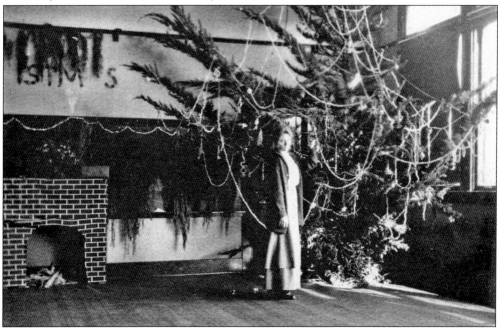

The Silverado School often received visitors. In 1915, the school was visited by members of the school board from El Modena and an inspection was made by the Orange County grand jury. At Christmas, the teacher and her students decorated the classroom before the winter break. This image depicts a visiting Ila Brown, from Orange, standing by the decorated Christmas tree. (Courtesy of the Local History Collection, Orange Public Library, Orange, California.)

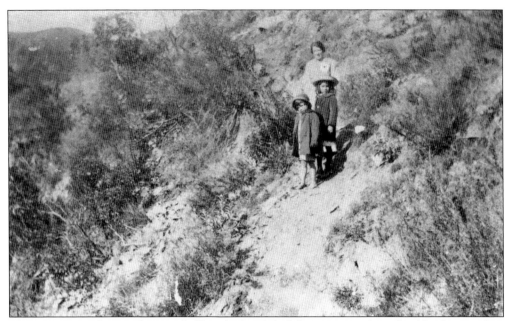

This 1919 image depicts Florence (left) and Alice Schulz being escorted to school by their mother, Naomi (Alsbach) Schulz. The Schulz children followed a mountain trail 1.5 miles long to arrive at school. Often encountering rattlesnakes along the way, they frequently called to their father to come and kill the reptile. This particular place on the ridge they named Rattlesnake Pass. (Courtesy of the Silverado Public Library.)

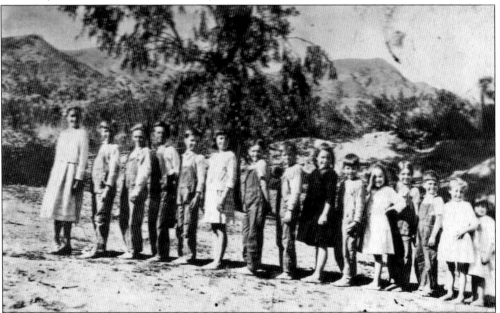

This 1919 photograph depicts the healthy and happy children of the Silverado School. The students are, from left to right, Evelyn Schulz, Joseph Holtz, Henry Mayer, Walter Johnson, Judd Miller, Evelyn Johnson, Vernon Schulz, Alban Holtz, Dorothy Mauerhan, Ray Mauerhan, Alice Schulz, Charles Miller, Ray Johnson, Margaret Holtz, and Florence Schulz. (Courtesy of the Silverado Public Library.)

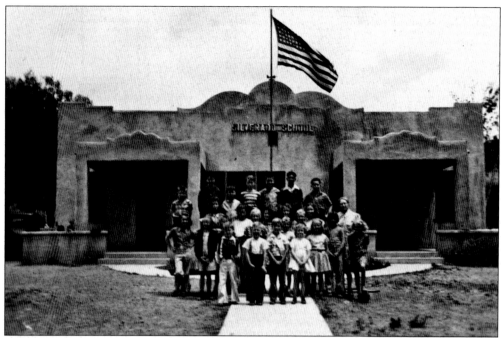

During the Depression of the 1930s, the Works Progress Administration enlarged and renovated the school, erecting a building in the Mission Revival style. John and Florence Harbottle arrived in 1925 and were both given jobs at the Silverado School, he as a maintenance engineer and bus driver, and she as a teacher and principal. Florence Harbottle is shown here with her class of 1938. (Courtesy of the Silverado Public Library.)

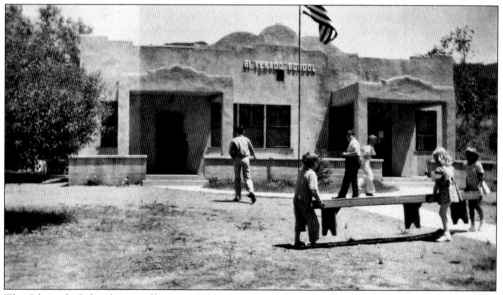

The Silverado School was well supported by the community. In the 1930s, a well was dug, and the school was given a drinking fountain. An organization founded by Tommy Beaulieu, called the Mother's Club, was formed to raise money for school supplies and equipment. After school hours, the structure was used as a town meeting place and voting center. (Courtesy of the Silverado Public Library.)

In 1904, Joseph Holtz built this ranch house and windmill. He married Mary Veith in January 1905, and they eventually had seven children, all of whom were born here. Built on or near the site of the Francisco Soto adobe, this adobe structure was used by Holtz as a cooler. (Courtesy of the Silverado Public Library.)

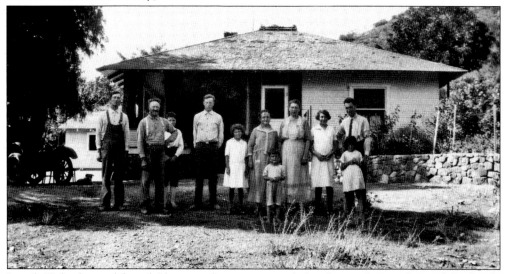

Joseph Holtz (second from left) is seen here posing with family members in front of the family home in this c. 1925 photograph. The well-tended rose garden of Mary Holtz is visible behind the fence on the right. (Courtesy of Tom and Elvira Holtz.)

The Holtz family home was large and inviting. Most teachers at the Silverado School boarded with the Holtz family, attracted by the close proximity to the school and the good cooking of Mary Holtz. The house was also the site of a weekly Mass, with a visiting Catholic priest officiating. (Courtesy of the Silverado Public Library.)

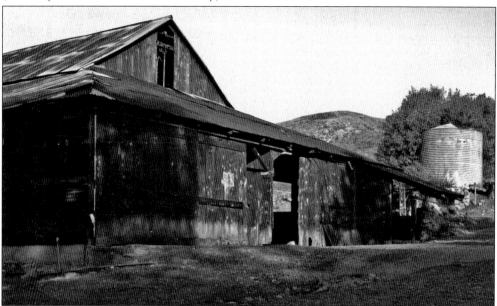

Joseph Holtz was a self-made rancher who became quite prosperous. He lived on and farmed his property throughout his adult life. This was the site of the first dairy and creamery in the canyon. Holtz sold milk, buttermilk, butter, and eggs. He also sold turkeys and chickens. Local delivery of these goods was made by bicycle. (Property of the Silverado Public Library.)

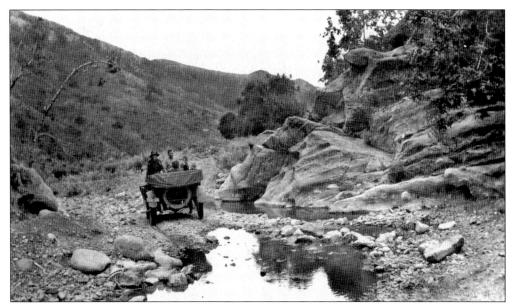

Prior to 1911, Joseph Holtz made trips to Orange for supplies once or twice a month using a horse and wagon. These trips took two days. In 1911, he purchased his first automobile, a 1909 Babcock, to travel more easily and frequently to Orange. Seen here on their way out of the canyon is the Holtz family navigating the creek that crosses the road. (Courtesy of Tom and Elvira Holtz.)

Joseph Holtz built a garage adjacent to his home. Originally used to house his buggy, it eventually housed the family automobile. Seen here in this 1980 photograph, the garage was built to accommodate one vehicle and provide additional living space. (Courtesy of the Silverado Public Library.)

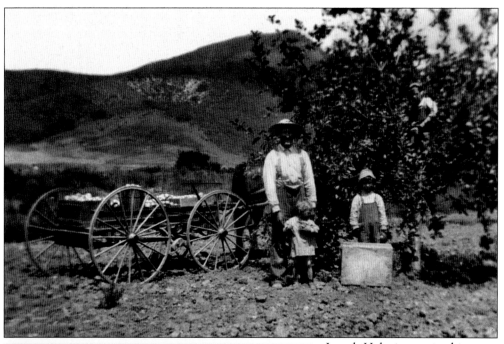

Joseph Holtz is seen in this c. 1910 photograph (above) harvesting fruit with the assistance of three of his children and his horse and wagon. Holtz allotted one acre of his land for fruit trees, with most of the harvested fruit kept for the use of his family. (Courtesy of Tom and Elvira Holtz.)

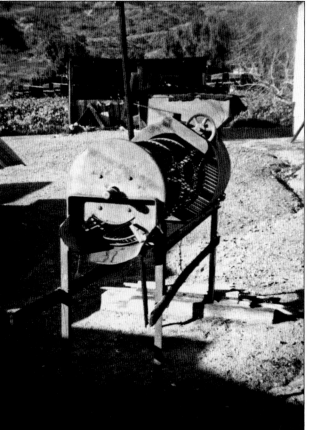

Large quantities of English walnuts were grown, harvested, and sold by the Holtz family. Walnuts intended for consumption must be husked immediately after harvest. This walnut husker was used to de-husk the walnuts. They were then rinsed in their shell, sorted to remove undesirable fruit, and dried for about a month before being sold. (Courtesy of the Silverado Public Library.)

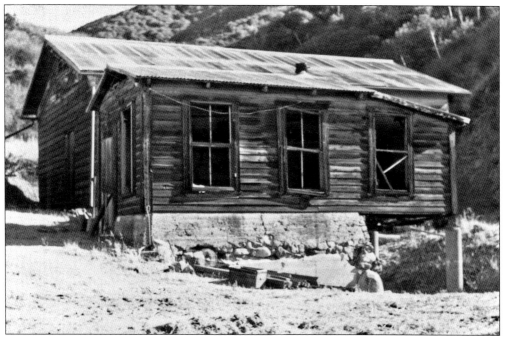

During the late 1920s, this room above the tank house housed a Chinese washer-man who worked for the Holtz family. Mary Jane Patton, a Holtz cousin who lived at the ranch as a young girl in 1929 and 1930, has fond memories of the music played on the phonograph kept in this room. (Courtesy of the Silverado Public Library.)

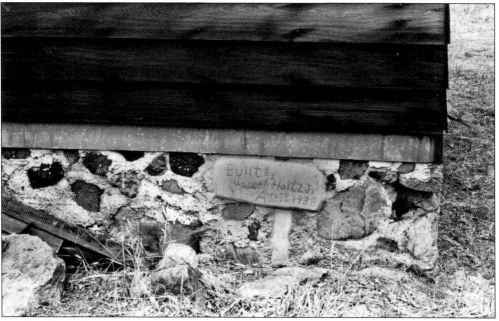

Joseph Holtz Jr., born in 1906, eventually took over the operation of the ranch from his father. He inherited his father's solid work ethic and was a proud man. Visible here is an inscription etched into some rock work done by him. It reads, "Built by Joseph Holtz Jr. April 1938." (Courtesy of the Silverado Public Library.)

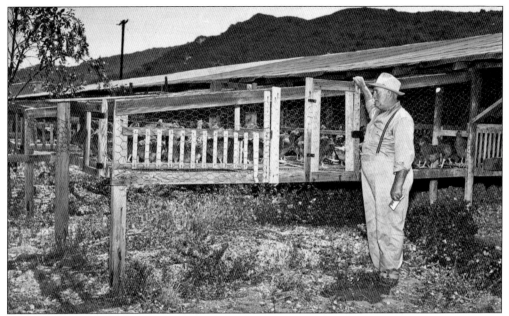

Beginning in 1950, Silverado residents Tommy Beaulieu and his wife, Marie, leased the Holtz property and raised turkeys and chickens. The chicken coops were well built and continued to provide a reliable place to raise poultry. Tommy Beaulieu is shown here admiring his fine flock of Rhode Island Red chickens. A hardy variety, the Rhode Island Red is a good choice for the small flock owner. (Courtesy of the Silverado Public Library.)

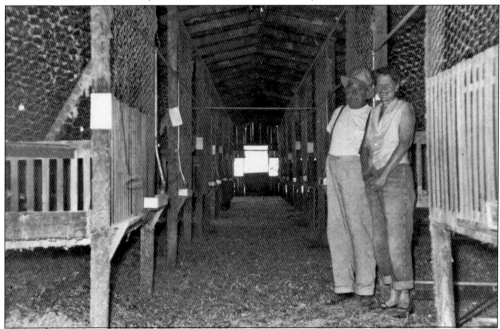

This image, taken in July 1950, shows Tommy and Marie Beaulieu seemingly enjoying their new business of raising chickens. Standing inside the chicken coop ready for work, they eagerly anticipate their first dozen eggs. Tommy would continue to lease and work the Holtz chicken coops until the death of Marie in 1963. (Courtesy of the Silverado Public Library.)

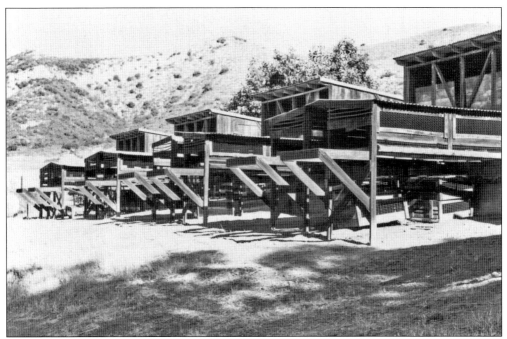

The Holtz chicken coops were left vacant after the departure of Tommy Beaulieu and his chicken-raising business. Tommy Beaulieu was the last person to raise either turkeys or chickens on the Holtz Ranch. This image, taken in 1980, shows the chicken and turkey coops in relatively good condition, a testament to the quality workmanship done by Joseph Holtz. (Courtesy of the Silverado Public Library.)

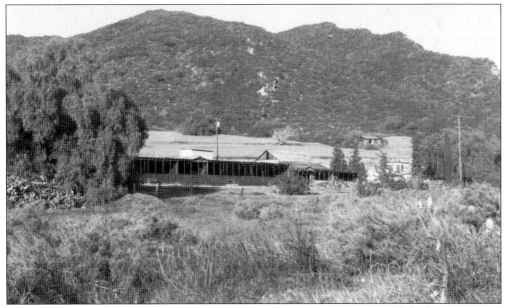

This 1983 partial view of the Holtz Ranch property shows the then unused chicken coops and turkey pens, along with the barely visible barn roof. The ranch house is hidden behind the trees on the far right. No longer used by either family or lessee, the ranch was sold in 1999. The majority of buildings on the property were demolished in 2007. (Courtesy of the Silverado Public Library.)

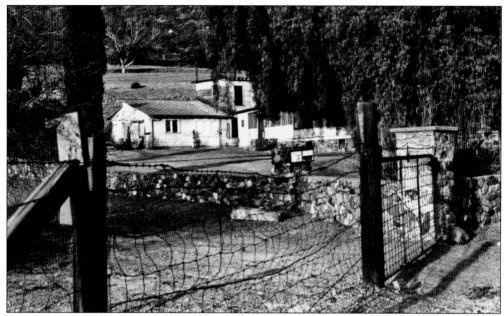

The rock work seen in this 1980 photograph forms a barrier between the Holtz Ranch residence, the farming area, and the Silverado Canyon Road. Beautifully crafted from local creek rock, it is a fine example of the work performed on the Holtz Ranch. Visible is the garage, with the house partially hidden by the tree on the right. (Courtesy of the Silverado Public Library.)

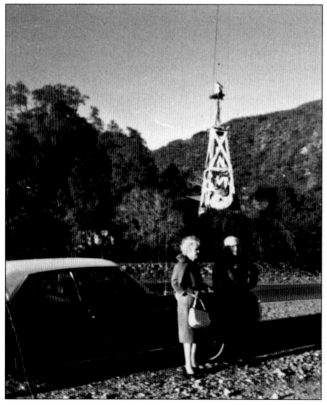

On December 25, 1972, Lester and Laura Slaback, whose picture, taken 64 years before, graces the cover of this book, visited Silverado and posed once again in front of the Holtz Ranch. This image was taken by their son Lecil, then a resident of the canyon. A trip that once took a good part of the day by horse and buggy now takes only 30 minutes by automobile. (Courtesy of Lecil and Neva Slaback.)

Three

BLACK STAR CANYON

Located just inside Silverado Canyon, Black Star Canyon has a history of its own. Before it was named Black Star, it was called Canon de los Indios by the Spaniards, meaning Canyon of the Indians. Black Star Canyon was home to a large Native American camp located at the upper end of the canyon. Mature oak trees surrounding a flat open space with slabs of bedrock made for an ideal village site. An almost year-round water supply is located nearby in the creek, which is home to a 60-foot waterfall. It was at this village site, in what is now known as Orange County, in 1832 that the only documented Native American massacre occurred.

The first European resident of Black Star Canyon was Juan Canedo. He arrived from Mission San Juan Capistrano in the early 1830s, built a cabin of sycamore logs, and named his home site Rancho Escondido. Over time, the ranch changed hands, eventually becoming known as Hidden Ranch. Another early settler of Black Star was Frank "Pancho" Carpenter. The son of an American trapper father and Spanish mother, he arrived in the early 1870s and homesteaded 160 acres. The discovery by Frank "Pancho" Carpenter of a vein of coal in the area led to the formation of the Black Star Coal Mining Company, giving the canyon its present name. The mining company dug 1,500 feet of tunnels and worked the mines until 1894.

In 1899, silence was broken in the canyon when a shoot-out occurred at the Hidden Ranch. A dispute regarding a pasturage bill resulted in the murder of James Gregg. The first murder trial was then held in the recently established Orange County.

Black Star Canyon is now home to a handful of residences.

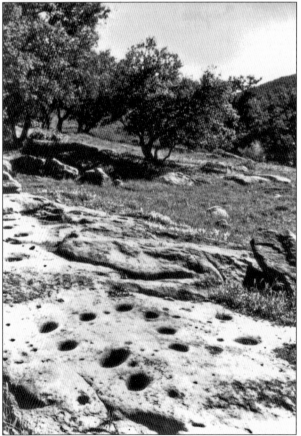

The Native American village site seen here was home to both the Juaneno and Gabrielino tribes. The flat open space surrounded by oak trees is located on a bluff near the creek and waterfall. In 1832, after reportedly stealing horses from white men near Irvine Park, a group of Native Americans were followed here and killed. This site has been designated California Historical Landmark No. 217 by the California State Park Commission. (Courtesy of First American Corporation.)

Visible in this 1962 photograph is an example of the abundance of Native American grinding holes, called morteros, at the village site. The California Indian harvested the acorn for food. Acorns were gathered in the fall, usually by women, after falling from the oak tree. The acorns were hulled and then ground using stone mortars and pestles at sites such as these. (Courtesy of First American Corporation.)

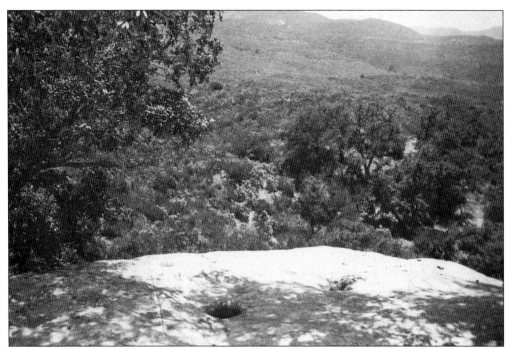

This set of morteros is situated on a bluff overlooking the canyon walls that surround the creek. A nearby water source was necessary for the acorn preparation process. After the acorns were ground, they then needed to be leached of their tannins. Acorns were rarely eaten raw because the tannins they contained were bitter and unpalatable. (Courtesy of First American Corporation.)

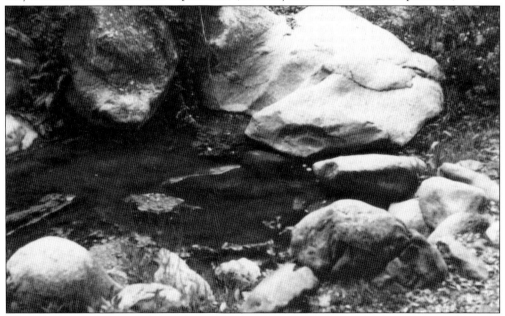

This 1963 photograph was taken in the creek below the village site, most likely one of many locations used by the Native Americans during the acorn leaching process. After the acorns were leached, they were sifted and mixed with water to form a paste. This process required as many as 10 applications of water, often obtained from a favorite spring. (Courtesy of First American Corporation.)

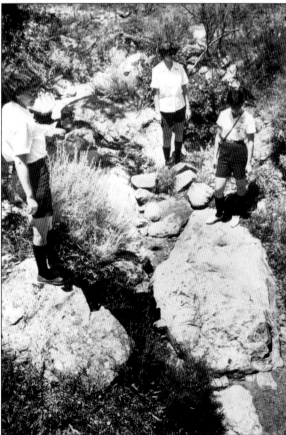

Local Girl Scout troops, attempting to earn the Indian Lore merit badge, occasionally visited Black Star Canyon. One requirement to obtain the Indian Lore merit badge was to visit a Native American museum or cultural site. In 1962, Senior Girl Scout Troop 87, sponsored by the First Baptist Church of Santa Ana, California, visited the Native American village site to meet that requirement. (Courtesy of First American Corporation.)

Learning the history, traditions, food, and habitat of a Native American tribe that lives or has lived nearby is a requirement to obtain the Girl Scouts of America Indian Lore merit badge. Exploring the creek located below the village site in 1962 are, from left to right, Troop 87 leader Barbara Blankman, Susan Blankman, and Pat O'Brien. (Courtesy of First American Corporation.)

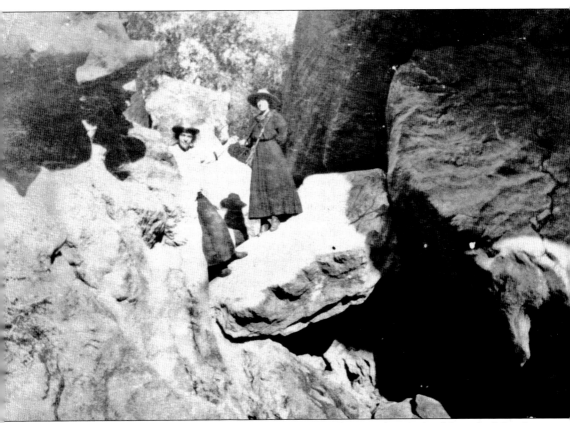

In 1915, Ruby Alsbach (left) of Silverado and a Miss Gowdy, a teacher at the Silverado School, spent a day exploring Black Star Canyon. Gowdy was a boarder at the Alsbach family ranch. Boarding with a nearby family was a common living arrangement for the teachers hired by the Silverado School. Sporting the fashion of the day—long skirts, leather boots, large brimmed hats, and a shoulder bag slung across the chest to keep their hands free—the ladies set off for a day of adventure. Hiking from the abandoned Native American village site, they lowered themselves into the chasm that forms the Black Star Creek. With walls that reach nearly 300 feet, huge boulders must be scaled in order to reach the bottom, where even in the driest year, water can be found trickling over and into a small fern grotto to form the second tallest waterfall in Orange County. Scrambling over boulders to reach the waterfall in Black Star Canyon is a challenging hike that is still attempted by many today. (Courtesy of the Silverado Public Library.)

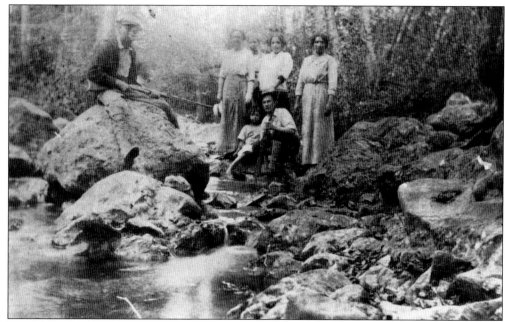

This photograph of members of the Shaw and Alsbach families was taken in the early 1900s at the creek in Black Star Canyon. Guns were carried and used to hunt rabbit and deer, and were oftentimes used as props in photographs such as this one. Posing as a group of hunters, they sent this photograph to relatives back east. (Courtesy of the Silverado Public Library.)

Frank "Pancho" Carpenter arrived in Orange County in the early 1870s and homesteaded 160 acres in Black Star Canyon. To build his home, pictured here, he used a combination of rock from a nearby streambed and adobe brick. Occupied as late as 1893 by his son Francisco, the house was later owned by Bob Shaw, a well-known fire warden of Santiago Canyon. (Courtesy of First American Corporation.)

Known as Beek's Place, this property was built in the 1930s by Newport Beach harbormaster Joseph A. Beek and was used as his hunting lodge and summer house. Located in upper Black Star Canyon and constructed using creek bedrock and plywood, the property provided him and his visitors beautiful views of the coastline and an ideal spot to test their hunting skills. (Courtesy of the Silverado Public Library.)

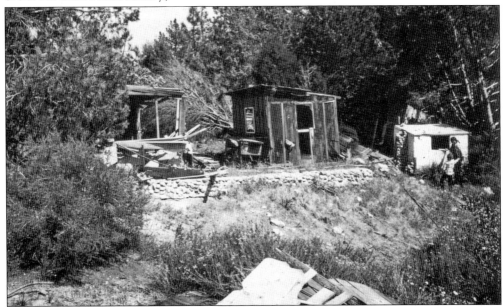

Taken in 1984, this photograph shows what remained of the structures located at Beek's Place. In addition to building a place for himself and his visitors to eat and sleep, he also added a steam house to his property. After a day of hunting, time spent in the steam house was a luxury indeed. Long since abandoned, the property often attracted the curious. (Courtesy of the Silverado Public Library.)

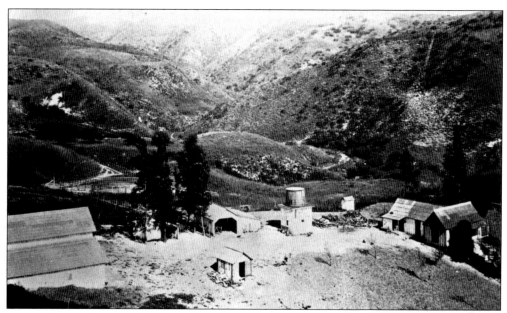

Located some distance from the Native American village, this ranch was first the home site of Juan Canedo, who arrived in the 1830s and called it Rancho Escondido. Situated in a basin surrounded by mountains and difficult to locate, the ranch passed through many hands before the first legal title was given to Baker Thompson. His cattle ranch is seen in this *c.* 1920 photograph. (Courtesy of First American Corporation.)

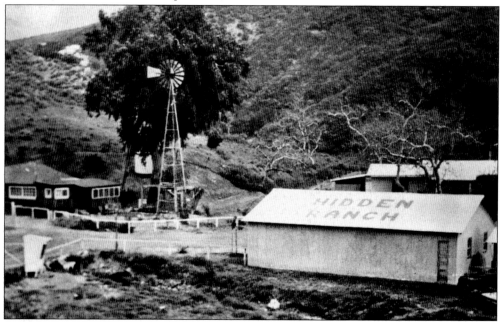

This 1966 photograph shows the site originally known as Rancho Escondido. Renamed Hidden Ranch in the 1870s, this ranch was the site of the 1899 shootout between then owner Henry Hungerford and stock driver James Gregg of Centralia. A dispute over a pasturage bill of $17.50 ended in the shooting death of Gregg. Although he was originally convicted of murder, Hungerford's conviction was eventually dismissed. (Courtesy of First American Corporation.)

The ranch house seen in this 1966 photograph was originally constructed in 1944 by then owner Don Larter. He returned home from war, began raising cattle, and built himself a square house with a four-sided roof and front porch. Still visible is the original roofline with the now enclosed front porch. (Courtesy of First American Corporation.)

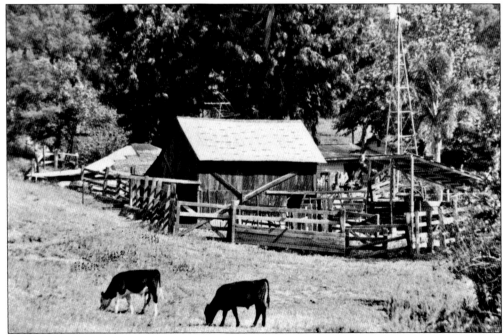

Cattle formed the major source of income for residents of Hidden Ranch. In 1984, when this photograph was taken, it appeared not much had changed since the dawn of the 20th century. Previous residents had established a well-made barn that was still in use, as were the outbuildings and windmill. (Courtesy of the Silverado Public Library.)

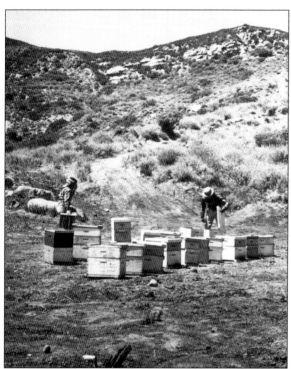

Most early settlers in Black Star found their livelihood in bees. August Witte arrived in 1876 to keep bees and was quite successful until a forest fire several years later destroyed most of his apiary. This *c.* 1940 photograph shows men keeping bees in the same fashion as had their predecessors nearly 70 years earlier. (Courtesy of First American Corporation.)

Prior to 1908, the grizzly bear was the greatest threat to a beekeeper. After the last grizzly was killed in the Santa Ana Mountains in 1908, the most harm a beekeeper might encounter was a stinging by the bees. In 1940, this Black Star Canyon beekeeper (below) protected himself with a net head covering while admiring the work of his bees. (Courtesy of First American Corporation.)

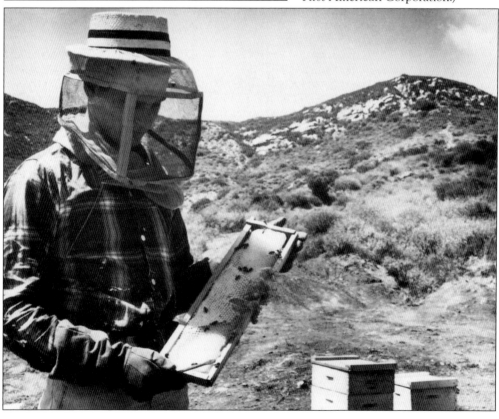

Four

MINING

The discovery of silver in 1877 turned the quiet canyon into a bustling mining town. Hank Smith and William Curry, residents of Santa Ana, found a piece of blue-white quartz while hunting in the canyon.

The assay results returned a positive conclusion: silver ore valued at approximately $60 a ton. Their discovery resulted in the biggest silver strike in the area that was to be called the Santa Rosa Mining District. Pharez Allen Clark of Anaheim arrived during this time and acquired a parcel of property at the end of the canyon. It was he who platted a town site, christening it Silverado City. By 1878, hundreds of men had arrived and staked claims. Silverado City, eventually shortened to Silverado, became home to three hotels, three stores, seven saloons, two blacksmith shops, meat markets, and various other industries associated with a mining town. Three stagecoaches ran daily from Santa Ana and two from Los Angeles. John D. Dunlap, a deputy U.S. marshal, located the mine that became the most profitable and the most famous. His Blue Light Mine, originally called the Silverado Mining and Milling Company, was established in 1878 and remained in operation under his supervision until 1901, long after the other mines failed.

In 1875, at the mouth of the canyon, coal was discovered by a man named Ramon Mesquida. He and a few friends formed the Santa Clara Coal Mining Company and began mining the area. In 1881, ownership of the company changed hands, with the new owners being the Southern Pacific Railroad Company. The town of Carbondale boomed into existence the same way Silverado had. Carbondale was home to its own hotels, saloons, and stores. Carbondale, in all respects, rivaled Silverado, but both mining towns would soon become ghost towns. Supplies of both silver and coal began to fade, and by 1883, the mining boom was over. According to the Los Angeles County Directory, in 1883, only 16 residents were listed for both Silverado and Carbondale.

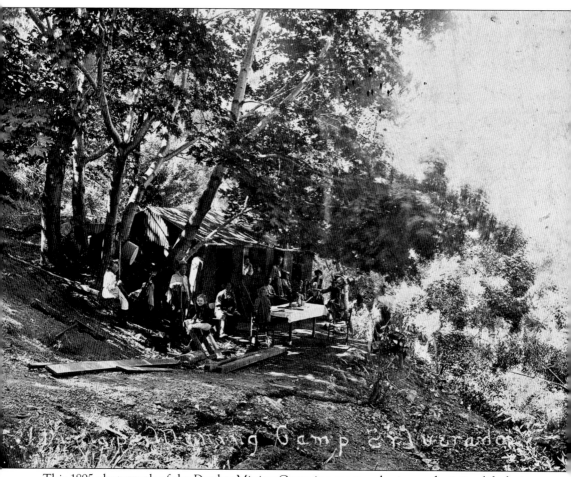

This 1895 photograph of the Dunlap Mining Camp is a spectacular image depicting life during the Silverado mining period. The men who arrived to work the mines came with their families. Because of limited resources and space, a corrugated tin structure has been built under the shade and protection of a mature sycamore tree to provide a home for several of those families. The women have added feminine touches to make the home as comfortable as possible. Visible behind the woman in the window is a curtain made of fabric. The table has been covered with a tablecloth, and a vase of fern fronds is used as the centerpiece. A swing has been built and is being enjoyed by the young girl on the far left. In the tree trunks surrounding the swing, various initials have been carved, as well as a date of 1888. (Courtesy of the Bowers Museum.)

This bag of ore was donated to the Bowers Museum in Santa Ana, California, by Jeanetta Dunlap, daughter of John D. Dunlap. It contains pulverized metal silver ore from the first mill in Silverado, which was established by her father. Ore samples such as these were taken to an assayer to determine their value, if any. (Courtesy of the Bowers Museum.)

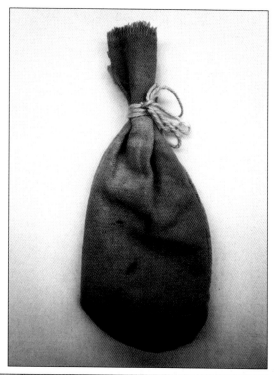

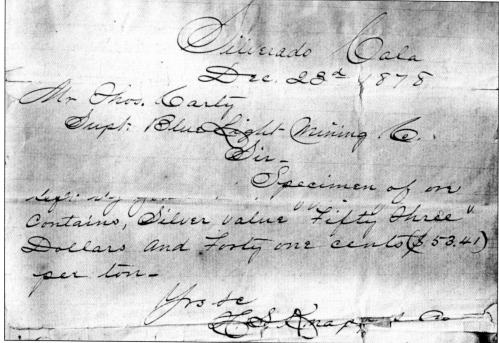

This receipt establishes the value of an ore sample taken from what would become the most profitable and most famous of all the Silverado mines. John D. Dunlap's recently established Blue Light Mine had this ore sample evaluated on December 23, 1878. The assayer determined the value at $53.41 per ton. (Courtesy of the Bowers Museum.)

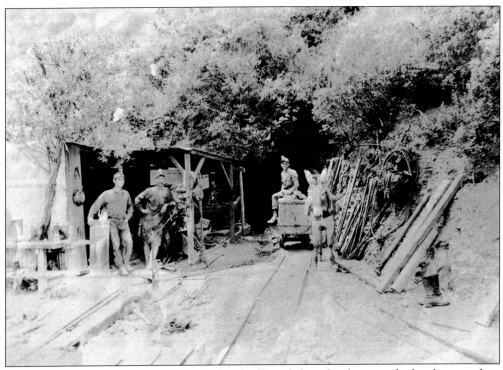

These miners appear to be enjoying the break allowed them by the arrival of a photographer. Posing proudly, they exhibit the strength and confidence one expects of someone willing to enter the earth as a way to earn a living. With their trusty mule jigs in attendance and a pipe at hand, they appear satisfied with their employment. (Courtesy of the Silverado Public Library.)

ASSAY OFFICE OF DR. O. H. CONGER.

Pasadena, Cal., *Oct 5th* 18*80*.

Specimen of *Ore from Silverado* deposited by *J. D. Bicknell Espr*

shows as follows:

2000 lbs. Avoir.-weight of the same Rock contains.

Troy		Ounces in Gold at $20.67	is	$
"	*391 38/100*	Ounces in Silver at $1.30	is	$ 513.81
"		Copper		
		Value per ton		$ 513.81

Charges *$2.50*

O. H. Conger M.E

By 1880, the price paid for a ton of silver from Silverado had increased dramatically. This receipt, dated October 5, 1880, from the Pasadena office of Dr. O. H. Conger, paid $513.81 per ton to J. D. Bicknell. Bicknell would soon become a member of the board of directors of the Dunlap Mining Company. (Courtesy of the Bowers Museum.)

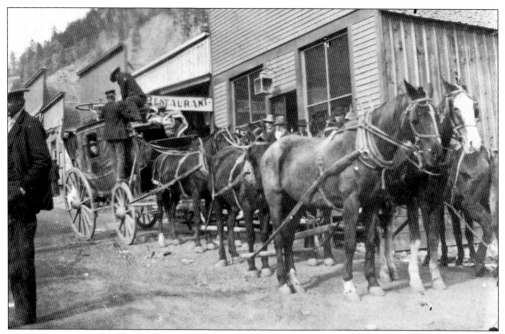

In 1878, the silver boom was on. Six-horse team stages brought people in and hauled the ore out to the railroad terminus in Santa Ana 18 miles away. The 18-mile trip took four hours. Stages ran thrice daily to Santa Ana and twice daily to Los Angeles. Silverado was now home to three hotels, three stores, two blacksmith shops, and seven saloons. (Courtesy of the Anaheim Public Library.)

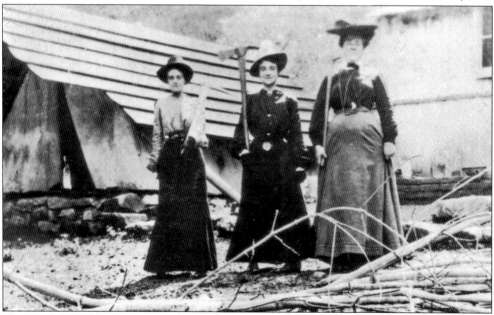

The possibility of fortune attracted even the ladies to mining. Whether posing or actually trying their hands at mining, these ladies standing outside a Silverado mining camp appear ready, willing, and up to the task. Though they are dressed perhaps a little too fashionably to enter a shaft, a trip to the assay office with a bag of ore might be right up their alley. (Courtesy of First American Corporation.)

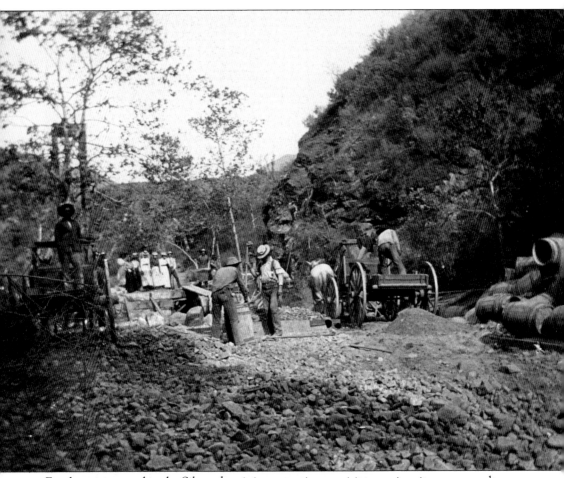

For those interested in the Silverado mining operations, a visit to a mine site was a novelty, a way to spend a day of leisure. Residents from nearby Orange and El Modena would occasionally spend a day in the canyon visiting the mines. Interested in the hoopla surrounding Silverado, they were offered a firsthand account of an authentic mining operation. Taken in 1900, this photograph depicts miners employed at the Blue Light Mine preparing their lode for transport down the hill while a group of spectators stand at a distance and watch. The unprocessed ore seen here has been extracted from the mountain and taken to this midway point by horse-drawn wagon. It is then shoveled into barrels and sent down a chute to the concentrating mill below, where it will be further processed and, with any luck, include large amounts of silver. (Courtesy of the Local History Collection, Orange Public Library, Orange, California.)

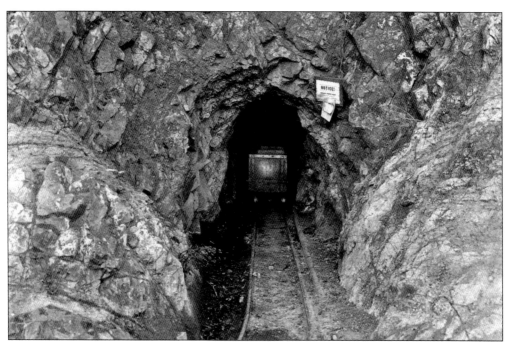

The Silverado Mining and Milling Company would eventually become known as the Blue Light Mine. It was originally developed with six tunnels that attained a depth of more than 350 feet. An ore cart on tracks is visible in this *c.* 1900 photograph, along with a notice stating that no admittance is allowed without permission from either the superintendent or the manager. (Courtesy of the Anaheim Public Library.)

The entrance to a mine shaft is called an adit. The Blue Light Mine had five levels of adits, ranging in elevation from 2,500 feet to 3,000 feet, and one mile of underground workings covering 61 acres. Interior wall collapses occurred occasionally, as evidenced in this photograph. This adit has been enhanced with support beams to guard against further collapse. (Courtesy of the Silverado Public Library.)

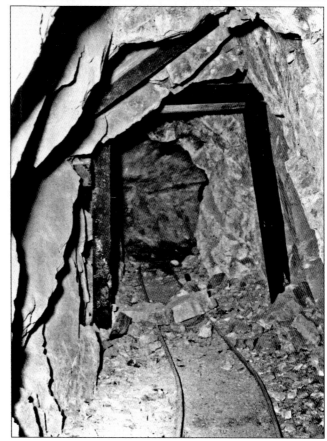

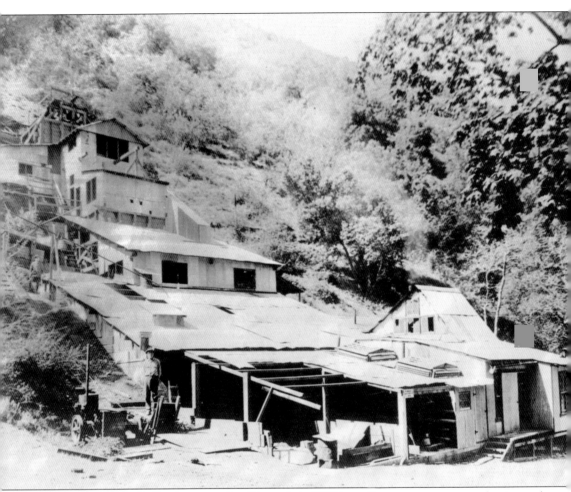

U.S. deputy John D. Dunlap arrived in Silverado in 1878 intending to serve a warrant but instead discovered ore that would make him the most successful of all the Silverado miners. First called the Dunlap Mining Company, then changed to the Silverado Mining and Milling Company, his mining operation eventually became known as the Blue Light Mine. His stake was located high on a southern ridge in Pine Canyon beneath Bear Flat. Dunlap formed a corporation that included himself and six trustees on December 27, 1880. They operated the mine at a profit until November 1901, when wanting out of the mining business, they leased the operation to Frank Porter. Porter leased the mine for only a year and a half, apparently losing favor with his lessors due to his lack of proper maintenance. The Blue Light Mine was sold to T. L. Reed of Reedly, California, in January 1907. This *c.* 1913 photograph depicts the flotation mill, the last stop for ore before it was transported to the assay office. (Courtesy of the Silverado Public Library.)

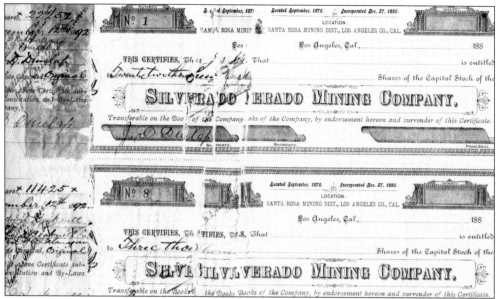

In 1892, the Silverado Mining Company determined funds were needed to further equip their mill with necessary machinery. It was decided that a block of 50,000 shares would be placed on the market at 30¢ per share, in anticipation of raising $12,000. This stock certificate book shows John Dunlap was the first to purchase shares of stock, followed by fellow director J. D. Bricknell. (Courtesy of the Bowers Museum.)

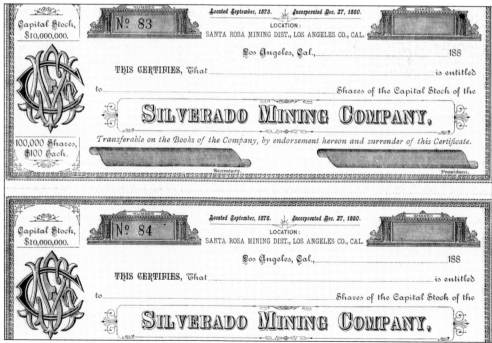

Stock certificates numbered one through 82 were successfully issued, as evidenced here by the remaining unused certificates beginning at number 83. They are beautifully decorated with the Silverado Mining Company logo on the left-hand side and include the September 1878 location date and the incorporation date of December 27, 1880. (Courtesy of the Bowers Museum.)

This chute was located near the lowest level of adits. It was used to transport the ore to the processing mill (also known as a flotation plant) below. The chute was fed by an overhead cable car that dumped its contents into a ball mill. Balls approximately 4 inches in diameter would then grind the ore in rubber-lined drums before it reached the flotation mill. (Courtesy of the Silverado Public Library.)

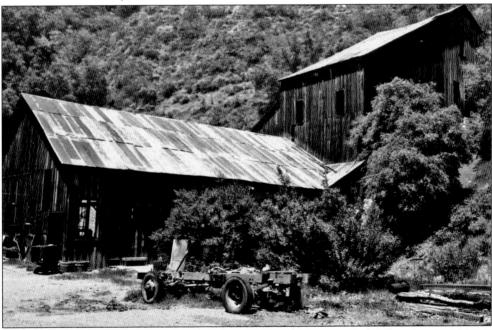

Long after the miners left, the buildings remained. The buildings in this 1980 photograph remind one of the optimism the mining companies had, erecting buildings such as these to house both equipment and men. When optimism turned to realism, they were quick to move on. Not bothering to take much with them when they left, they left even vehicles abandoned on-site. (Courtesy of First American Corporation.)

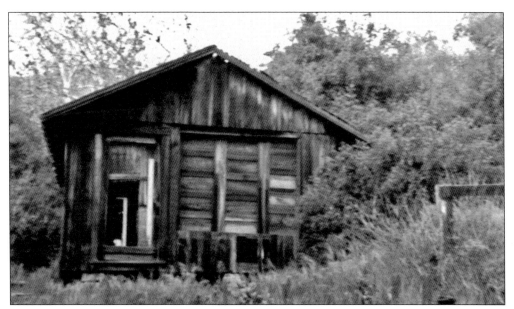

This abandoned bunkhouse was home to many miners during the silver boom. Still in fairly good condition in this 1980 photograph, it is another example of what happens after a bust: quick to arrive, even quicker to leave. During the early 1900s, people went where there was work. When most of the mines failed, the miners were quick to move on to the next opportunity for employment. (Courtesy of the Silverado Public Library.)

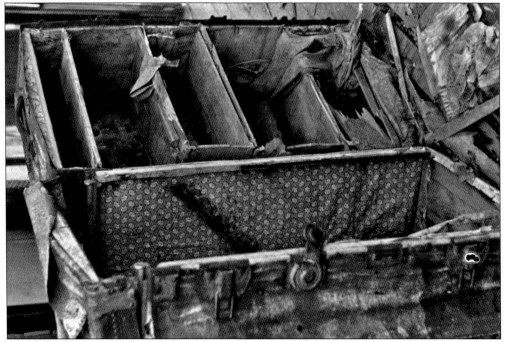

This empty suitcase, found in the abandoned bunkhouse, is one of the many mysteries that linger in the Mine Tract area of Silverado. Perhaps the owner went bankrupt while attempting to make his fortune in the Santa Rosa Mining District. Owning nothing requires one to no longer possess a trunk. (Courtesy of the Silverado Public Library.)

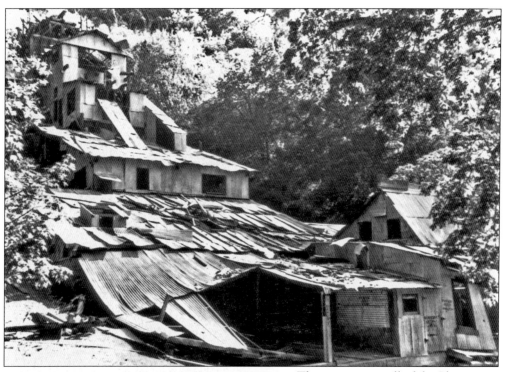

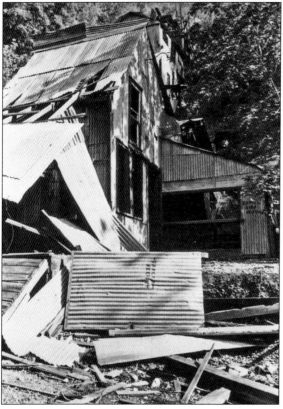

The processing mill of the Blue Light Mine continued to be worked intermittently until the 1940s. By the 1950s, it had become a curiosity. This photograph, taken in the 1960s, reminded residents and visitors alike of the sometimes forgotten mining history of Silverado. In 1968, the property was transferred by then owner Stanley Chapman to the U.S. Forest Service. (Courtesy of First American Corporation.)

Mining enthusiasts and adventurous sorts enjoyed exploring the abandoned mine relics. One such enthusiast who visited in 1956 reported entering the processing mill and finding shaker tables with ore still in place. Eventually, warnings were posted to discourage people from entering the buildings, such as the one seen here, decorated with "Danger—Keep Out." (Courtesy of First American Title.)

In 1972, the U.S. Forest Service, now responsible for the safekeeping of the Blue Light Mine property, decided it was in the best interest of everyone to remove the temptation that the buildings had become to sightseers and explorers. One canyon resident watched and photographed as the processing mill was dismantled. (Courtesy of the Silverado Public Library.)

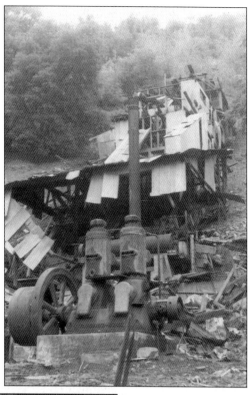

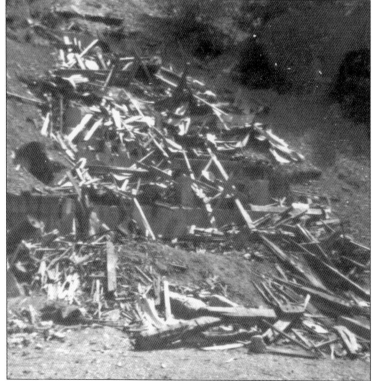

Machinery was sold, and remnants of the Blue Light Mine were acquired by local eating and entertainment establishments. The final demolition required 1,200 pounds of ammonium nitrate and three cases of DuPont dynamite. This photograph, taken in 1980, shows what remains of the most successful of all the Silverado mines. (Courtesy of the Silverado Public Library.)

This is the site of Carbondale, the coal mining town that rivaled Silverado in the early 1880s. Coal was first discovered here by Ramon Mesquida in 1878. He, with the help of William Curry (who had first discovered silver ore farther up the canyon), Henry Cassidy, W. O. Crewell, William Newkirk, and J. G. Kimball, filed a legal claim and formed the Santa Clara Coal Mining Company. They prospered until 1881, when the Southern Pacific Railroad resurveyed the property and determined the Santa Clara was operating on railroad land. The railroad company named their newly acquired town Carbondale and set about establishing a mining camp. The new town of Carbondale was soon home to a boardinghouse, general store, blacksmith, saloons, and a post office. Eventually, the coal ran out, and by 1886, Carbondale was an abandoned ghost town. The site of Carbondale has been designated California Historical Landmark No. 228 by the California State Park Commission. (Courtesy of the Bowers Museum.)

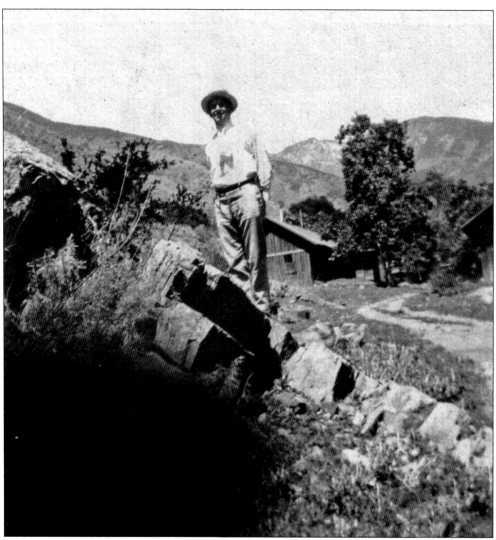

Before becoming a resident of Silverado Canyon, Lester Slaback, then residing in Santa Ana, would rent a horse and buggy and spend the day exploring the area. Visiting the canyon was a favorite pastime of his and his fiancée, Laura Huntington, who accompanied him on many of his visits. He is pictured here in 1908 at the site of what was once the coal mining town of Carbondale. Photographed by Huntington, he is standing with his back to what remained of the hotel in the bustling town of Carbondale. Both he and Huntington were drawn time and time again to the canyon and eventually settled here after they were married in 1909. Slaback became a court reporter at the age of 17 and was employed at the Orange County Courthouse in Santa Ana. He holds the record for being the longest-term county employee, officially retiring at the age of 70. (Courtesy of Lecil and Neva Slaback.)

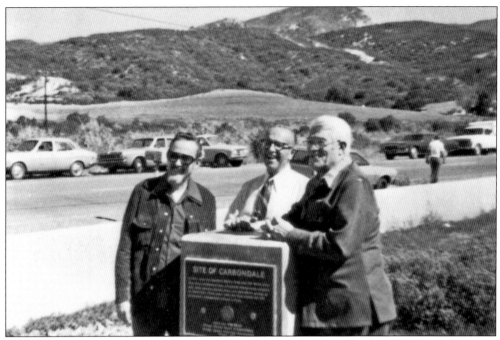

In 1976, the site of Carbondale was designated as California Historical Landmark No. 228 by the California State Park Commission. A ceremony was held in the parking lot of the Silverado Community Church, which now stands on the historic site. Pictured here from left to right are author-historian Jim Sleeper, Silverado resident Lecil Slaback, and Orange County superintendent Gen. Thomas Riley. (Courtesy of First American Corporation.)

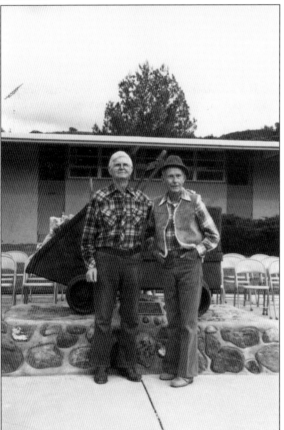

In 1982, a mining cart was presented to the Silverado Elementary School. Salvaged from the Blue Light Mine by Wally Aylstock and given to Bob Myers, Bob Morris, and Charlie Crump, it was then donated to the Inter-Canyon League, who organized a dedication ceremony. Present at the ceremony and pictured here are Herbie (left) and Carl Pember, both of whom worked the Blue Light Mine. (Courtesy of the Silverado Public Library.)

Five

A COMMUNITY GROWS

The 1920s brought about a newfound interest in the canyon. With the advent of the automobile and improvement of the roads, Silverado became more accessible to those interested in a weekend getaway. Abandoned mining cabins were transformed into quaint cottages featuring natural wood such as oak, sycamore, and maple used in the original construction. Stone fireplaces fashioned from creek rock were the source of heat during the cool winter months. The natural sulfur springs were rediscovered, and once again, Silverado was being promoted as a health resort. Hotels and dining establishments suitable to a more sophisticated palate were built. Developers arrived and established tracts sold as cabin sites "in a peaceful valley." Promoting Silverado was easy. A setting of matchless beauty, surrounded by mountain, forest, and stream, was often used to describe the canyon in advertising, as was the fact that Silverado was fog-free, its air dry and invigorating. A place of carefree pleasure and relaxation eventually became home to year-round residents interested in a lifestyle in harmony with nature. As the permanent population grew, so did the need for non-recreational facilities. The elementary school was renovated and upgraded, and a public library was established. A volunteer fire department was organized in 1949 to meet the need for a community firefighting service.

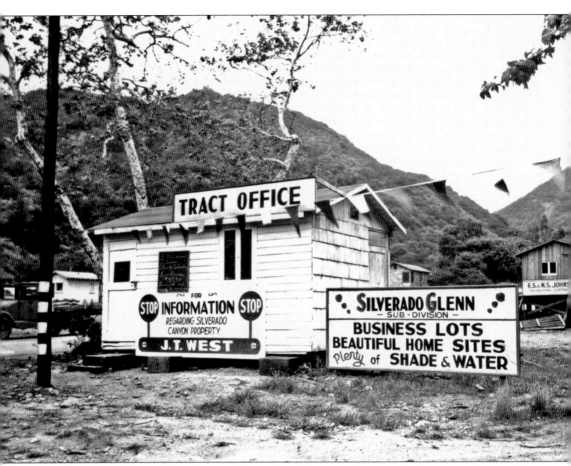

By the 1920s, Silverado had been subdivided, and lots were being sold. This tract office could not be missed as one drove into the canyon. Operated by J. T. West, this was the first opportunity a prospective buyer had upon entering the canyon. He advertised his subdivision as Silverado Glenn, where a lot was beautiful and had plenty of shade and water. Conveniently located just past his real estate office was the office of E. S. and N. S. Johnson, engineering contractors willing to build the home of your dreams. If the undertaking of home construction was not for you, West advertised ready-to-occupy properties as well. The property featured on the blackboard is a two-bedroom cabin with full shade for sale at the full price of $3,750. West was not the only game in town. Farther up canyon, a cabin or lot could be purchased from Albert Hough. He named his tract Albula and advertised the area as a community of canyon cabins in a peaceful valley. (Courtesy of First American Corporation.)

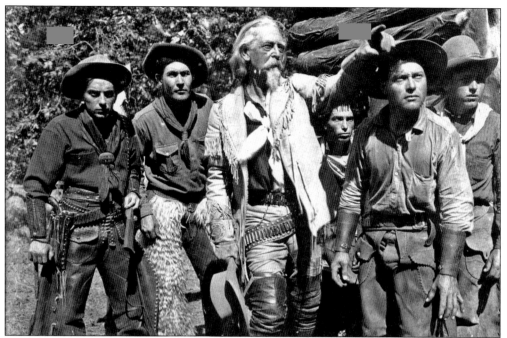

Hollywood discovered the canyon in the early 1900s not only as a getaway, but also as a potential backdrop. Scenes from the 1913 version of the Cecil B. DeMille film *The Squaw Man* were shot in Silverado. This still photograph was taken during that film shoot. Second from left is Art Acord, a well-known rodeo rider. (Courtesy of the Local History Collection, Orange Public Library, Orange, California.)

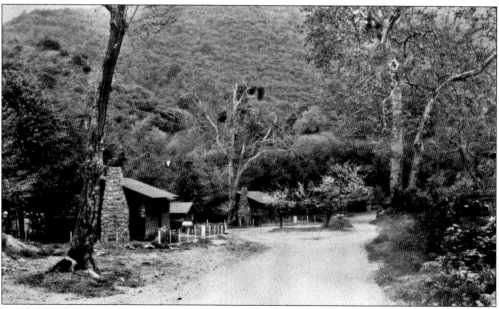

People from Orange County and Los Angeles were attracted to cabins like these for use as weekend getaways. This was a typical scene in Silverado in the late 1910s and early 1920s. Secluded cabins were situated at the base of canyon walls near the creek and were surrounded by native oaks and sycamores. (Courtesy of First American Corporation.)

This 1940s image depicts a typical canyon cottage conveniently situated next to the canyon road. A handcrafted stone fireplace was a feature of most homes built during the early 1900s. They were constructed from local creek rock and generally were the sole source of heat for the home. A beautiful work of art, the fireplace often became the centerpiece of many a canyon home. (Courtesy of First American Corporation.)

The shade of a mature oak tree provides natural air-conditioning for this 1930s period home. A home placed at a slight elevation also benefits from the breeze that blows naturally through the canyon from an easterly direction. This home was one of the few in the canyon built without a fireplace. (Courtesy of First American Corporation.)

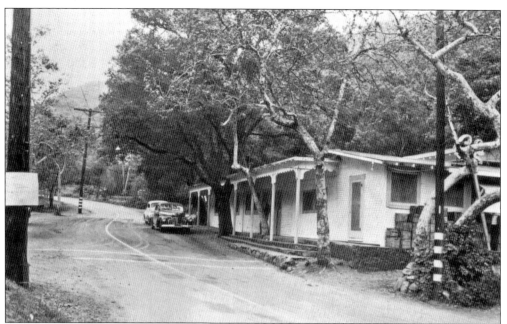

Eating and drinking establishments were added to the canyon to meet the needs of the growing population of residents and visitors. Smokey's, pictured here in this up canyon view taken in 1939, was one such popular establishment that also sold groceries. Smokey's was located midway through the canyon, across from what is now known as Sycamore Drive. (Courtesy of First American Corporation.)

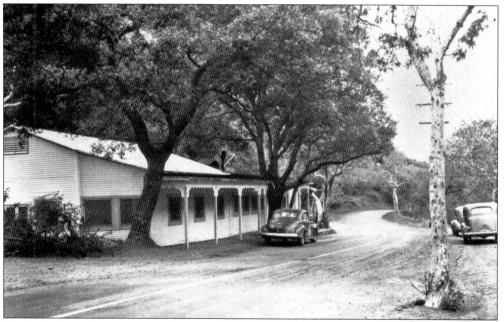

Smokey's featured a grocery at the west end of the building and a restaurant and dance hall at the east end. Smokey's was well known by the locals for its hamburgers, and the Saturday night dances were well attended by locals and visitors alike. This 1939 image features the restaurant and dance hall. (Courtesy of First American Corporation.)

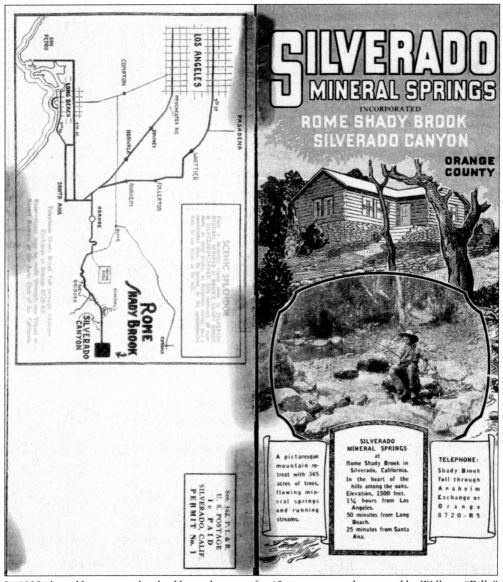

In 1935, the sulfur springs that had been dormant for 40 years were rediscovered by William "Billy" Miller. The son of Rome Miller, vice president of the Los Angeles Biltmore Hotel Company, he had been sent on behalf of his father to scout out potential business opportunities in Silverado. Taking advantage of this newfound discovery, he established the Silverado Mineral Springs, located at Rome Shady Brook in Silverado Canyon. Advertised and promoted on a grand scale, the mineral waters were purported to have astounding curing benefits. Guests were housed in the large up-to-date hotel located on-site or in a nearby mountain cabin. Room rates started at $1.50 per day. Bath rates were additional, as were the services of the on-site health professional, Dr. Frank Schaffell. Advertised as "our haven in the hills," as seen here in this brochure, Silverado Canyon began gaining fame as a health resort. (Courtesy of Jean Hobson Farr.)

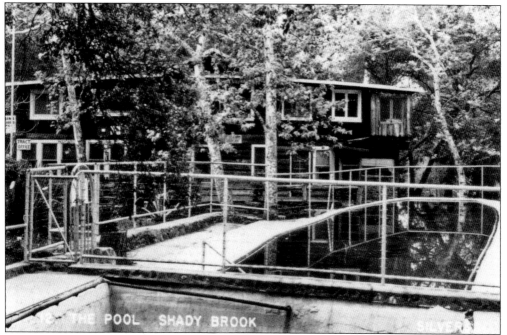

This early-1940s photograph depicts the swimming pool located at the Rome Shady Brook Hotel. Situated at the corner of Silverado Canyon Road and Hazel Bell Drive, the swimming pool was filled with mountain spring mineral water and was available for the use of non-guests at a price of 10¢ per day. (Courtesy of First American Corporation.)

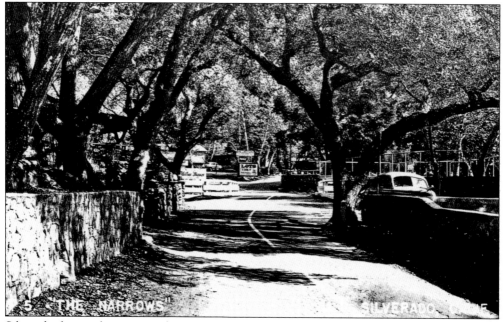

Silverado during the 1930s and 1940s was booming. Visible in this image are signs advertising the newly established tract named Miller Manor and lots available for the purchase price of $350. This aptly named part of the road is still known today as "the Narrows" and is located near Shady Brook. (Courtesy of First American Corporation.)

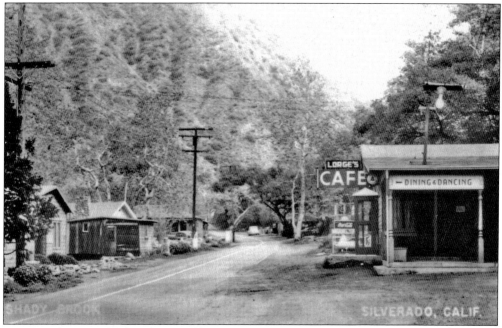

Lorge's Café, an establishment owned by Billy Miller, was located just up the road from his hotel and met the needs of local residents and of nearby hotel guests alike. During the late 1930s, the canyon was home to three public telephone booths, one of which can be seen here. (Courtesy of First American Corporation.)

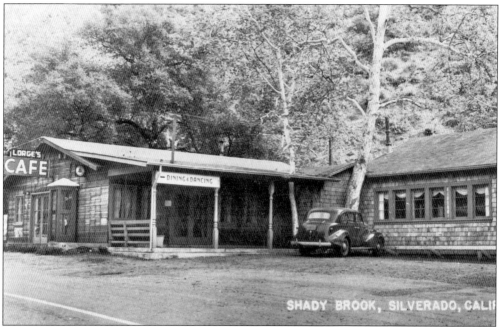

Lorge's Café was popular, offering dining and dancing to its clientele. The restaurant was situated in the front room, and a bench outside on the porch was useful when waiting for a table on a busy night. The room on the right featured a bar and dance hall where Saturday night dances were held. (Courtesy of First American Corporation.)

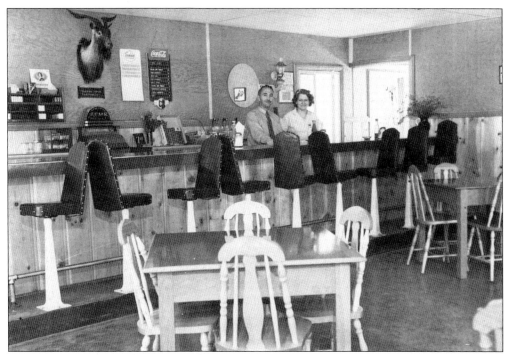

Tommy and Marie Beaulieu are seen here in this 1930s photograph behind the counter of Lorge's Cafe. Billy Miller and Tommy Beaulieu formed a long-standing business partnership that included the transformation of this establishment from a diner into a dance hall. (Courtesy of the Silverado Public Library.)

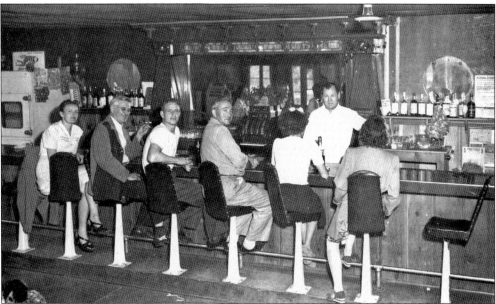

A bar stool appears to be hard to come by at Lorge's Café. Tommy Beaulieu, seated fourth from left, and other patrons are seen here enjoying conversation and an adult beverage in a relaxed atmosphere at one of the canyon hot spots holding a liquor license during the 1940s. (Courtesy of the Silverado Public Library.)

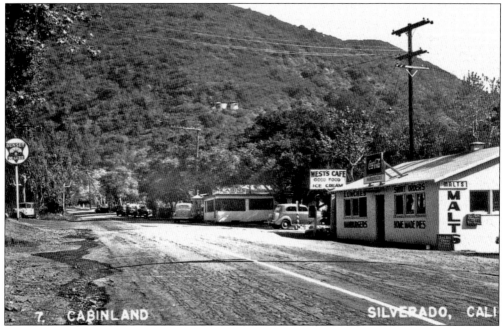

Beginning in the late 1930s, good food was to be had at West's Café, which was owned and operated by Jim West. Gas was now available in the canyon, as were cabin rentals in this area known as "cabinland." West continued to dabble in real estate by advertising available property on the blackboard outside his restaurant. West's Café is now known as the Silverado Café. (Courtesy of First American Corporation.)

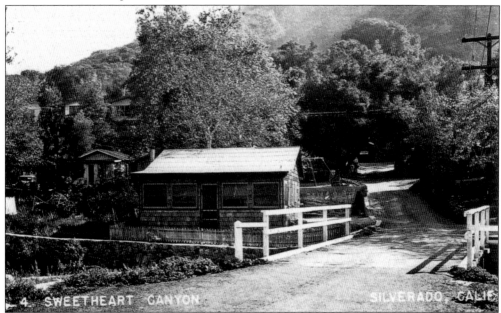

The area known in the 1930s as Sweetheart Canyon, pictured here, was a tract of homes located near the center of town. Situated below a north-facing canyon wall, these quaint cabins were accessed by crossing a narrow bridge that spanned the Silverado Creek. Many of these homes still exist, some in their original condition. (Courtesy of First American Corporation.)

Every thriving community during the 1930s needed a barber, including Silverado. Centrally located across the creek behind West's Café, this barbershop had a good business selling not only haircuts, but novelties and souvenirs as well. This barbershop exists today as a private residence. (Courtesy of First American Corporation.)

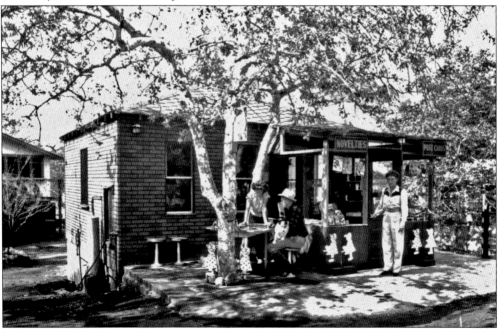

Selling postcards, magazines, and novelties in addition to haircuts allowed the proprietors of the barbershop to reap the added benefits that came with living in a tourist destination. This side-view photograph of the barbershop depicts the owner enjoying a game of checkers with his dog and a friend, while his wife waits for the next customer. (Courtesy of First American Corporation.)

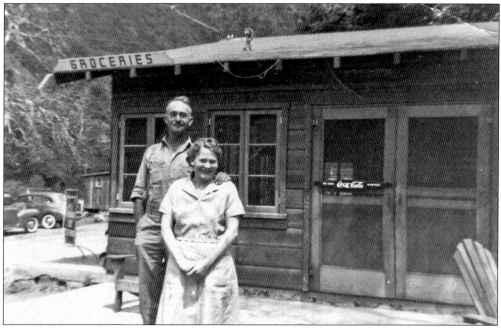

Tommy and Marie Beaulieu, pictured here in 1948, stand in front of the grocery store located in the former restaurant portion of Lorge's Café. After becoming a business partner with Billy Miller, Tommy Beaulieu added the grocery, and Lorge's became known as Tommy's Café. The Beaulieus would become well known for their community service and generosity in the canyon. (Courtesy of the Silverado Public Library.)

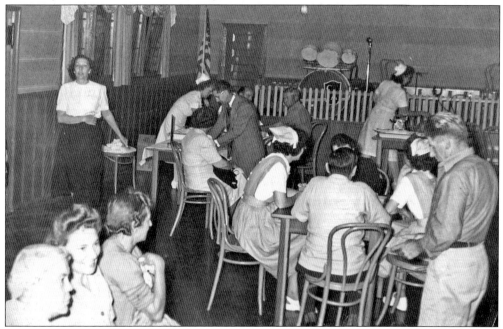

In 1942, a blood bank was organized by Tommy Beaulieu and was held at Tommy's Café. Seen here are nurses ready to take and citizens ready to give. The stage in the background is set up for an evening dance to be held after the blood drive. (Courtesy of the Silverado Public Library.)

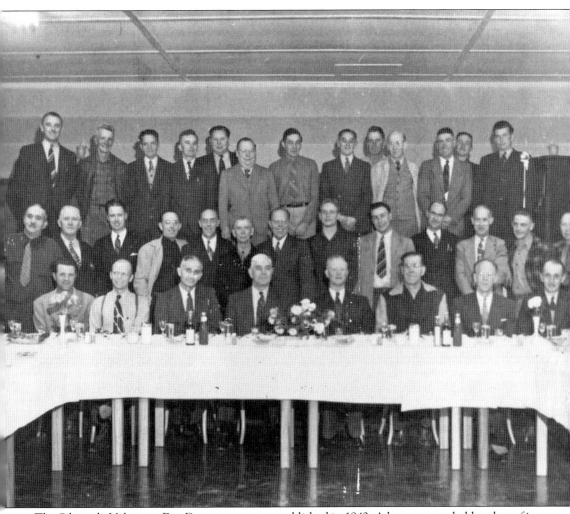

The Silverado Volunteer Fire Department was established in 1942. A banquet was held at the café owned by Tommy Beaulieu to celebrate the men of the community who were charter members involved with the formation of the fire department. Pictured here from left to right are (first row) Carl Shoop, Louie Shipman, Ranger Joe Sherman, Superintendent H. Willard Smith, Max Waite, Roy Grundy, Ken Hines, and James Chestnutt; (second row) Tommy Beaulieu, Jim West, Elmer Osterman, Carl Odem, Otto Puchert, Frank Schmitt, Monty Moltree, unidentified, Andrew Holtz, R. E. Doss, Frank Curran, Zip Koontz, and L. S. Schrode; (third row) Eddie Bachman, Orville Pember, Edward Freeman, Mort Armstrong, E. P. Horrocks, Billy Miller, Smokey Eaten, Earl Pingle, William ("Bud") Loke, unidentified, Glen Antle, Henry Mayer, and William Rafferty. The Silverado Volunteer Fire Department continues to operate today with a corps consisting of canyon residents. (Courtesy of the Silverado Public Library.)

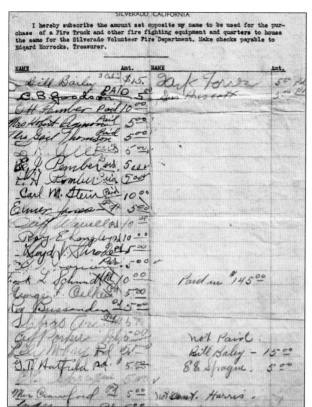

In 1944, community members joined together and established a fund for the purchase of a fire truck, equipment, and housing for same. This list depicts those who committed to the fund and the amounts pledged. (Courtesy of the Silverado Firefighters Association.)

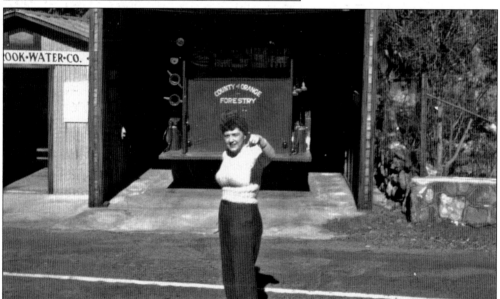

The Silverado Volunteer Fire Department was established and eventually became part of the County of Orange Forestry Department. Pictured here is an unidentified woman posing proudly in front of the fire truck purchased with the help of a fund established by the community. The original garage was located creek-side next to the Shady Brook Water Company. (Courtesy of the Silverado Public Library.)

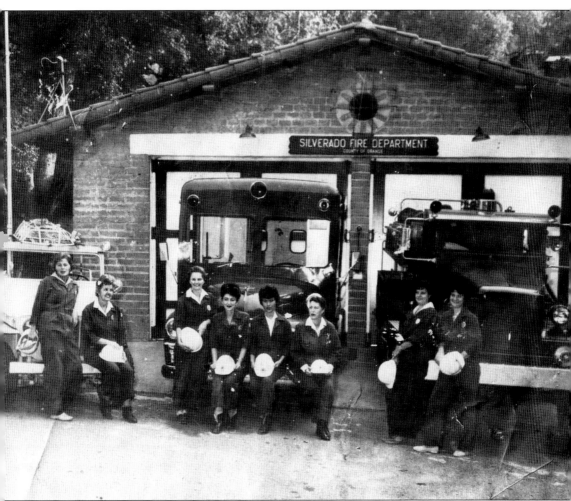

In 1957, the constant threat of fire during the daytime, when most volunteer firemen were at work, propelled the wives of these men, who were home during the day, to form an auxiliary group of volunteers consisting only of women. With membership limited to 12, six women, all of whom were wives of volunteer firemen, met for the first group training session in June 1957. The California Division of Forestry assigned fire prevention patrolman Louie Shipman to provide instruction in basic firefighting fundamentals and rescue operations. On September 29, 1958, the Orange County Board of Supervisors approved and authorized the Silverado Auxiliary Fire Department with the same benefits and compensations as any volunteer department. Pictured here in 1959 in full uniform are, from left to right, Jean Hobson, Mary Read, Janie Schrowe, Helen Radke, Bobbie Horax, Doris Olsen, Jane Carter, and Carol Brinkema. (Courtesy of the Silverado Firefighters Association.)

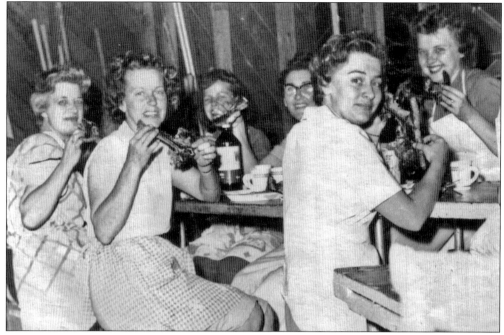

Giving new meaning to "ladies who lunch," these ladies-in-training of the Silverado Auxiliary Fire Department enjoy lunch and laughs after a meeting in this 1958 photograph. Pictured from left to right are Lil Pingle, Gracie Pember, unidentified, Pat Miller, Jean Hobson, and Ann Collar. (Courtesy of the Silverado Firefighters Association.)

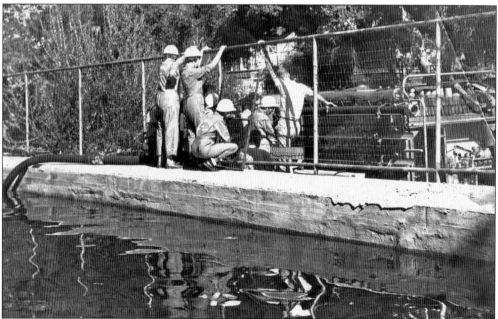

Drafting water is a common practice used by rural fire departments. Availing themselves of the water in the pool of the Rome Shady Brook Hotel, the ladies of the Silverado Auxiliary Fire Department learn the process of moving water from one location to another. (Courtesy of the Silverado Firefighters Association.)

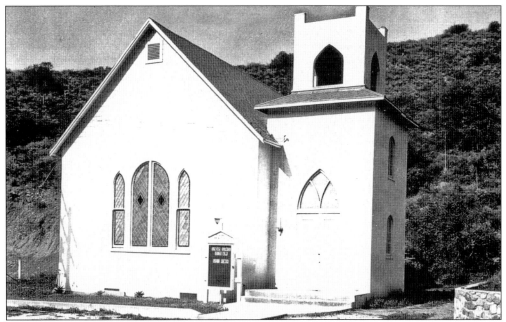

This church was originally constructed in 1886 and is the second oldest church building in Orange County. It was donated by the community of Villa Park to Silverado Canyon in the 1930s. Renamed Silverado Community Church, it held nondenominational services here each Sunday at 9:00 a.m. (Courtesy of First American Corporation.)

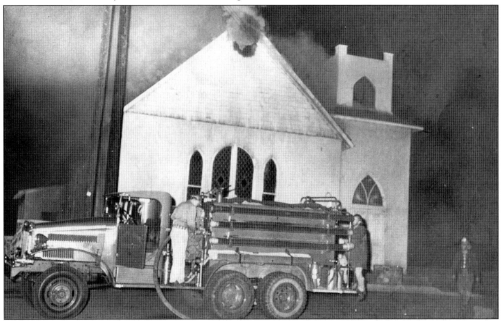

On September 22, 1961, an early morning blaze destroyed the Silverado Community Church. The fire was reported at 3:15 a.m. by a neighbor, and eventually, 11 fire units responded. Pictured here is the first unit to respond, the Silverado unit located at the Mine Tract Station, preparing to battle the blaze. Set on fire when an oil heater flooded and then exploded, the church could not be saved. (Courtesy of the Silverado Firefighters Association.)

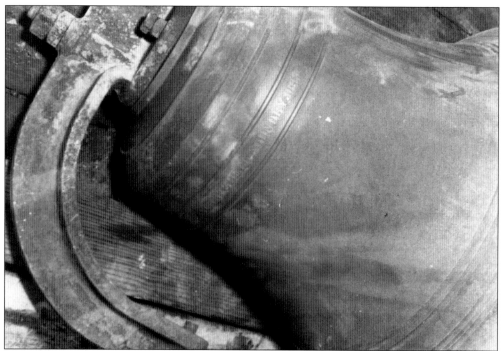

Although many priceless items, such as a 100-year-old Bible, were lost in the Silverado church fire, the bell that hung in the bell tower was salvaged. Visible in this 1961 photograph are the words "Buckeye Bell Foundry" and the date 1893 stamped into the bell. (Courtesy of the Silverado Firefighters Association.)

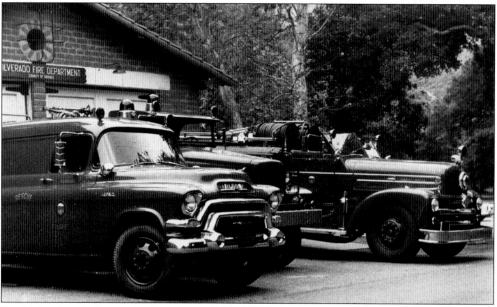

Washed and ready for action, this rescue squad and two fire engines belonging to the Silverado Fire Department are proudly displayed in front of the station for all to see in a c. 1960 photograph. The Silverado Fire Department is kept busy responding to automobile accidents and fires. (Courtesy of the Silverado Firefighters Association.)

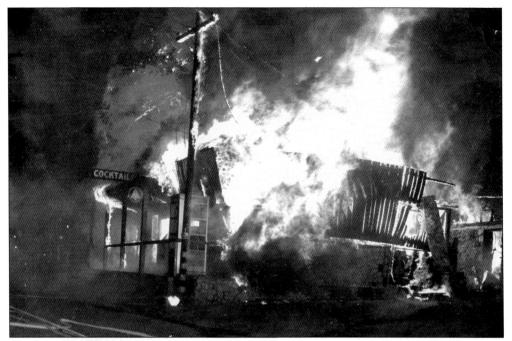

Fire destroys a canyon eatery in 1960 as Smokey's bar and restaurant, seen here, goes up in flames. When firefighters arrived on the scene, they discovered no water in the hydrant located nearby. As it was certainly suspicious and never solved, some residents still believe arson was the cause of the fire. (Courtesy of the Silverado Firefighters Association.)

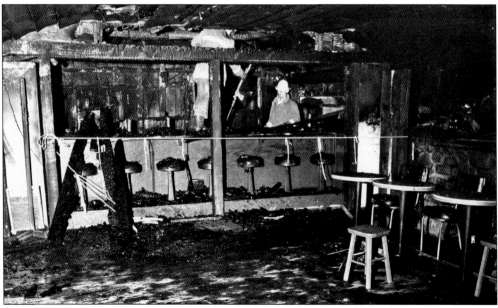

In 1971, another canyon restaurant was damaged by fire. The Alpine Inn was a popular restaurant and bar well known for outdoor barbeques, horseshoe games, and live music. Although the interior was badly damaged, as seen in this image, the restaurant was remodeled and was back in business for approximately 10 years before being turned into a private residence. (Courtesy of the Silverado Firefighters Association.)

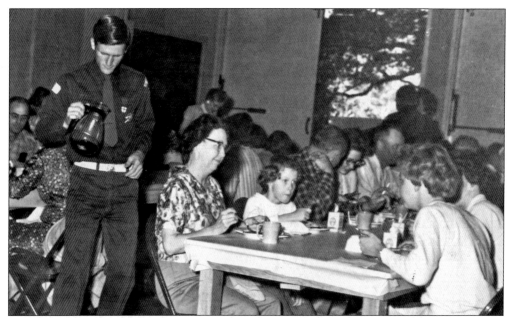

Easter breakfast served by the Silverado firefighters is an annual event. Established as a fund-raiser, breakfast was originally served in the fire station. As attendance grew, breakfast was eventually moved outside, then to the forestry station, and is now served at the community center. In this 1961 photograph, a firefighter attempting to re-offer coffee determines his pot is almost empty. (Courtesy of the Silverado Firefighters Association.)

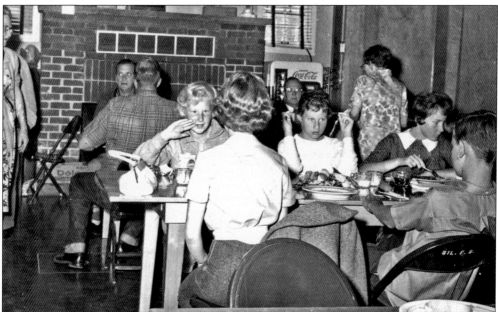

Betty Lee Foor (left) and Sharol Hobson (center), both facing the camera, along with other canyon residents, enjoy Easter breakfast at the Silverado Fire Station in 1961. A breakfast that includes scrambled eggs, pancakes, sausage, and bacon is made and served by the members of the Silverado Volunteer Fire Department. It is a tradition that carries on today. (Courtesy of the Silverado Firefighters Association.)

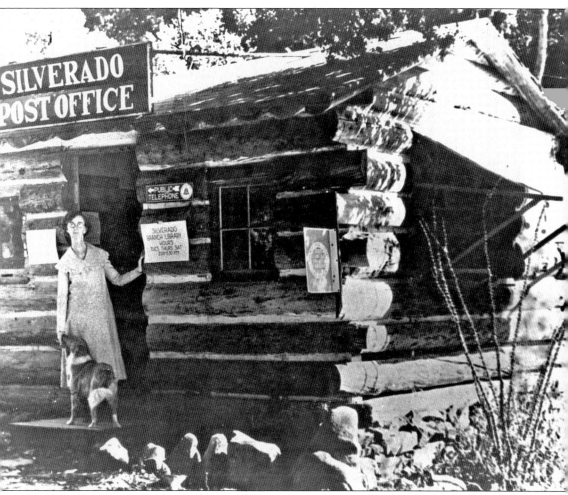

In 1929, Elsie McClelland, seen here with her dog, established the first library service in the canyon. Situated in the log cabin that was the post office, the Silverado Library was accepted into the Orange County Public Library system in 1930. McClelland was the postmistress in 1929 and tended to the mail in a log cabin on a lot in the Shady Brook neighborhood that had been donated by a canyon businessman. Deciding the canyon would benefit from a library, she contacted Margaret Morrison, a friend and county librarian. Morrison donated 60 books to McClelland, who shelved them in the post office. A sign posted out front made known the library was open for business on Tuesday, Thursday, and Saturday from 2:00 p.m. until 5:30 p.m. The Silverado Library would continue to operate in the log cabin with McClelland as the librarian until her retirement in 1946. The cabin was then given to McClelland and was moved to Hazel Bell Drive, where she lived until her death on January 15, 1961. (Courtesy of the Silverado Public Library.)

Afternoon story time—a once-weekly library activity provided by library staff and volunteers that includes storytelling, outdoor activities, and crafts—is held on a patio overlooking the creek on this summer afternoon in 1952. Story time continues to be offered to canyon kids today. (Courtesy of the Silverado Public Library.)

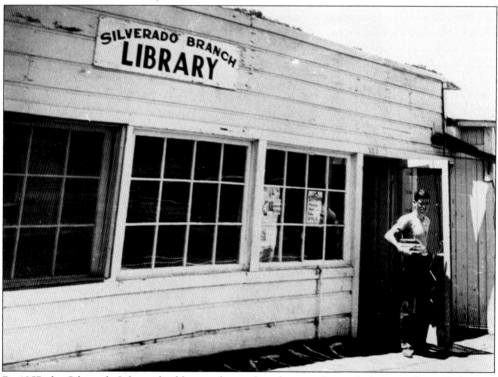

By 1957, the Silverado Library had been relocated to the storefront of what was formerly known as West's Café. Roger Parsons is seen here exiting the library one July afternoon with a handful of books. A sign in the window announces that the library is open on Monday, Wednesday, and Friday from 2:00 p.m. until 5:00 p.m. (Courtesy of the Silverado Public Library.)

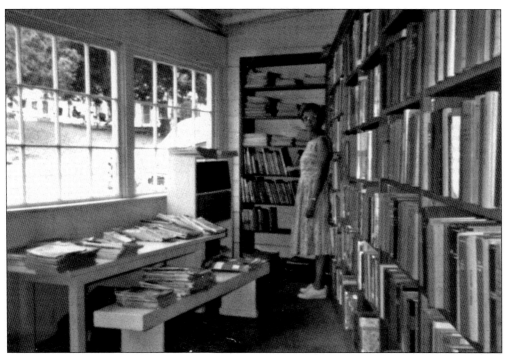

Librarian Gerry Klingensmith is seen here in this *c.* 1960 photograph amid neatly arranged shelves of books and a table and bench piled with magazines. Seen through the windows of the library are the Silverado Courts, the only apartment complex in the canyon. (Courtesy of the Silverado Public Library.)

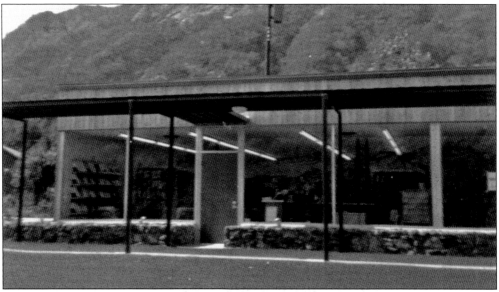

The Silverado Shopping Center was built in 1964 by Victor Lobdell, and the County of Orange agreed to lease a portion of the center to be used as the Silverado Library. As it was the first building in the canyon to be equipped with an air-conditioning unit, canyon readers were encouraged to visit the library and experience reading in comfort. Seen here in this 1965 photograph, the Silverado Public Library continues to operate in this location. (Courtesy of the Silverado Public Library.)

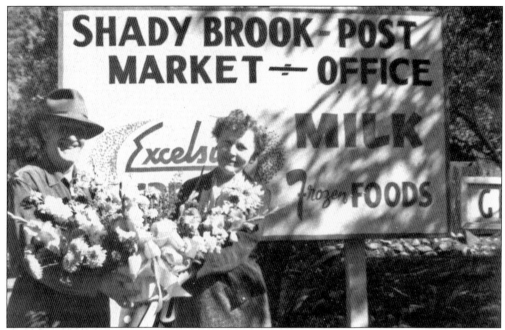

Guy Sparks was born on January 7, 1884, in Lynnville, Iowa. He served in the cavalry in World War I, dabbled in the stock market, and moved to Long Beach, California, during the oil rush of the 1940s. In 1949, he and his wife, Ruth, moved to Silverado and bought the Shady Brook Market. They are pictured here in 1957. (Courtesy of the Silverado Public Library.)

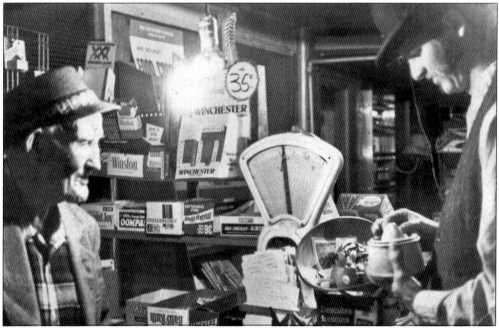

The Shady Brook Market was owned and operated by Guy Sparks (left) for the remainder of his life. The market was open seven days a week, 12 hours a day. He occasionally allowed himself a Sunday afternoon of leisure to watch a football game. He is seen here conversing with a customer in this late-1960s photograph. (Courtesy of the Silverado Public Library.)

Guy Sparks became known as the poet laureate of Silverado Canyon and was honored at the first annual Silverado Country Fair in 1971. He discovered poetry late in life and was eventually featured on stage and television. He is seen here in 1974 inside the Shady Brook Market, where he would sign and sell his books of poetry. (Courtesy of the Silverado Public Library.)

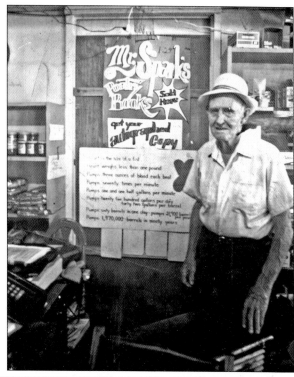

Known as Mr. Sparks to canyon kids, Guy was a well respected and beloved canyon resident, and it was a pleasure to spend time with him and listen to his stories. He lived in an apartment above the store and could often be found out front visiting, even after closing. He is seen here in 1974 with several canyon kids. Guy Sparks died on April 5, 1975. (Courtesy of the Bowers Museum.)

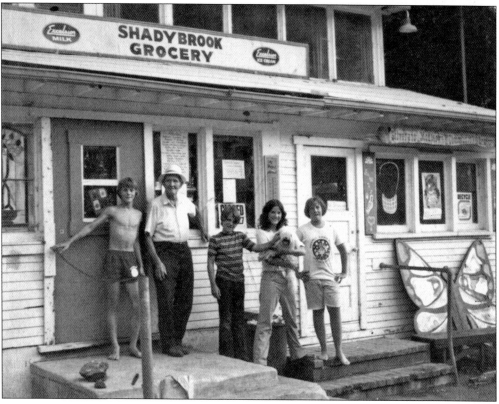

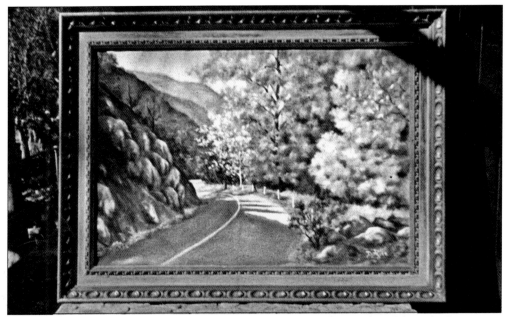

Artist Dorothy Rice was born in New York City in 1919 and moved to Silverado Canyon in 1960. A primarily self-taught painter, she opened an art gallery in the canyon that featured her work. Her best-known work features canyon scenes, such as the one seen here on this late-1960s postcard. (Courtesy of the Silverado Public Library.)

Beautiful Silverado Canyon nestled in the Santa Ana mountains. Referred to as Orange County's Mecca of Health for its dry, moderate desert-like climate. So close to the cities, yet another world. The silver rush is over but the area still reeks of mining history and enchantment.

LITHO HENRY McGREW PRINTING, K. C. 8. MO.

PLACE STAMP HERE

POST CARD

41193

The reverse side of the postcard promotes Silverado as Orange County's "Mecca of Health" because of its dry, moderate climate. It is close to the city, yet worlds apart, and it still reeks of mining history and enchantment. Dorothy Rice paintings became a desired item for many a canyon resident and visitor alike. She resided in the canyon until her death in October 2007. (Courtesy of the Silverado Public Library.)

Six

THE FLOOD OF 1969

February 1969 brought a torrential downpour to Orange County. A nine-day storm brought death and devastation to Silverado Canyon. During one 72-hour period, 18 inches of rain fell into Silverado Creek.

One hundred residents chose to vacate their homes and were forced to take shelter in the community center, the post office, and the fire station. Of those, 35 chose the Silverado Fire Station as their safe haven, only to be victims of a landslide that pummeled the building with mud. Five people perished, most of whom were volunteer firefighters. Residences were destroyed, some literally washed away, and bridges collapsed or disappeared altogether, leaving the entire area isolated and in shambles. On February 28, three days after the mud slide, the recovery of the victims in the fire station was completed. Canyon residents mourned the loss of their friends and neighbors. Although shocked and saddened, they joined together and began cleaning up. Tractors were donated by local businesses, and canyon residents used equipment of their own to assist those in need. Afterward, the Army Corps of Engineers helped re-channel the creek and built bridges that could better withstand flooding. In 1970, a new fire station was constructed adjacent to its previous location. A dedication and ribbon-cutting ceremony took place on July 18, 1970. A plaque dedicated to those who perished graces the entrance.

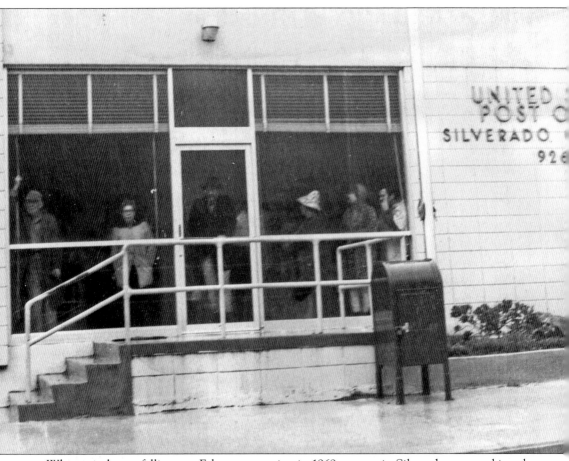

When rain began falling one February morning in 1969, no one in Silverado expected it to last as long as it did and cause the damage it would. As residents began realizing it was no longer safe to stay in their homes, some left the canyon and headed "downtown" to escape the downpour. Those who chose to remain would eventually find themselves taking shelter in one of three places: the fire station, the community center, or the post office. Although the post office was closed for business, permission was granted to local resident and firefighter Greg Petersen to open the building and use it as a temporary shelter. Seen here escaping from the rain are, from left to right, Ray Ogan, Jeanie Prater, unidentified, Florence Lobdell, and two unidentified. (Courtesy of the Silverado Public Library.)

Clouds and mist obscure the top of the mountain, the creek swells, and hillsides bearing homes risk the possibility of landslide. This home, located on Hidea Way and belonging to Jeanie Prater, looks on the verge of slipping down the hill. (Courtesy of the Silverado Public Library.)

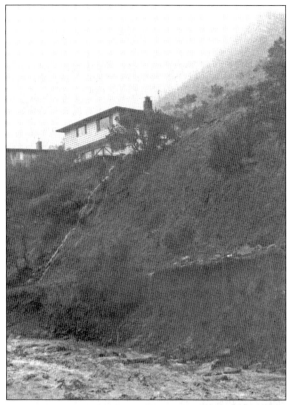

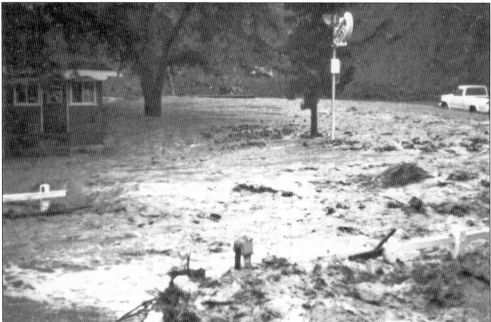

The Silverado Creek flows up and over the bridge and into the parking lot of the Alpine Inn, a favorite canyon dining spot. Though damaged, the Alpine Inn would return to business, only to be damaged a few years later by fire. (Courtesy of the Silverado Firefighters Association.)

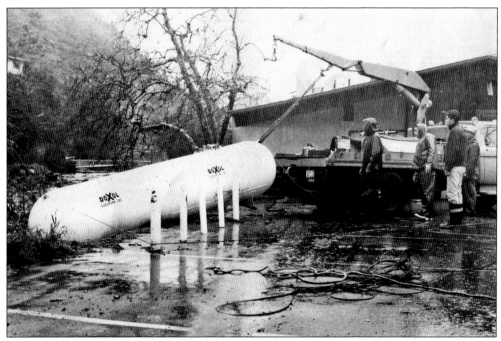

Borrowing equipment from neighbor Charlie Stotts, local residents, from left to right, Greg Petersen, unidentified, Bob Scott, and Charlie Stotts hook up a crane and a chain to try to save a propane tank from sliding into the creek behind Victor's restaurant in the Silverado Shopping Center. (Courtesy of the Silverado Public Library.)

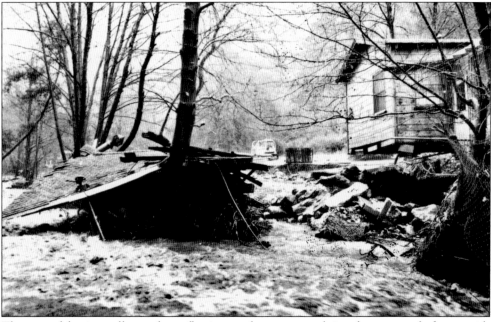

The powerful rain-swollen and overflowing creek attempts to bring down part of a house with its roof and smokestack still attached, only to be stopped by a tree. A small bulldozer parked in the background waits for the rain to abate and for an opportunity to begin providing some sort of assistance. (Courtesy of the Silverado Public Library.)

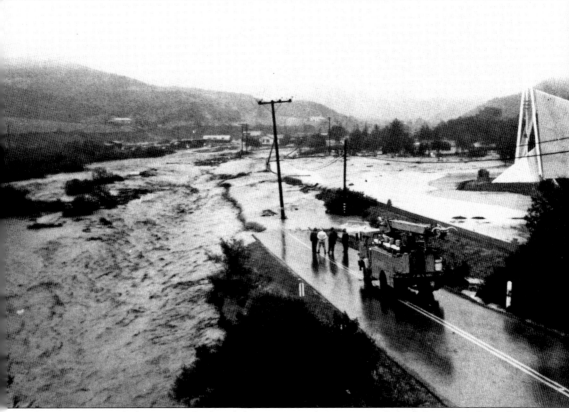

The area previously known as Carbondale is seen in this picture taking a battering from the out-of-control water of the Silverado Creek. A public utility vehicle is stopped in its tracks as it attempts to make its way farther into the canyon. The creek has swallowed up portions of Silverado Canyon Road, making access into or out of the canyon impossible. The Silverado Community Church is visible on the right, seemingly spared from any flood damage. This contemporary-style church was built in 1961 to replace the historic church destroyed by fire earlier that same year. Both it and the land it sits on were donated to the community of Silverado. The bell hanging from the steeple is the same bell dated 1893 that hung in the bell tower of the destroyed church. (Courtesy of the Silverado Public Library.)

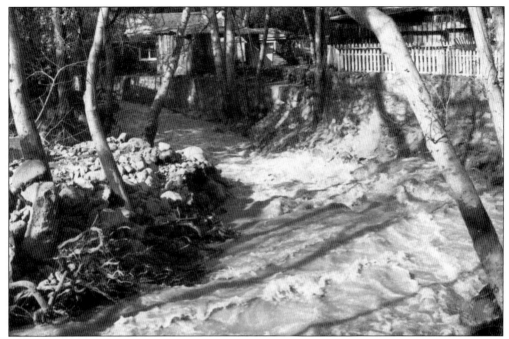

Wildcat Creek merges into Silverado Creek and threatens homes in the Shady Brook Drive neighborhood. The onslaught of rushing water jeopardizes rock retaining walls and mature trees. Exposed roots and eroded banks make obvious the destructive power of the water. (Courtesy of the Silverado Public Library.)

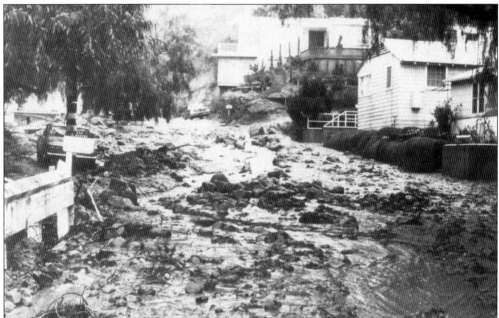

The evidence of Mother Nature's fury is visible in this image, taken after the rain stopped. Silverado Canyon Road is unrecognizable to anyone who does not travel it regularly. The houses along this portion of the road appear not to have suffered any damage, but it will be days before the cars will be put to use. (Courtesy of the Silverado Public Library.)

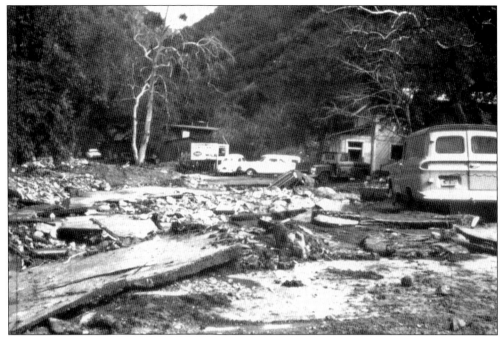

The badly damaged Silverado Canyon Road is seen here in front of the undamaged Shady Brook Grocery. Guy Sparks, owner of the market, offered provisions to anyone in need during the flood. Barely visible in the center of the photograph is the fender of a vehicle partially buried in the debris. (Courtesy of the Silverado Public Library.)

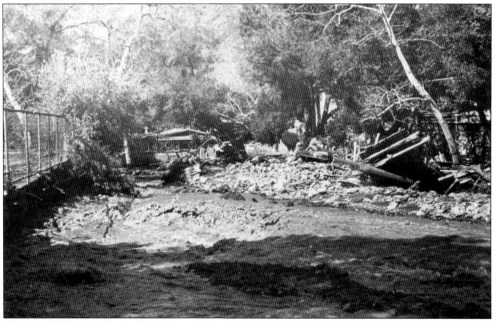

The mud-filled creek overflows onto Silverado Canyon Road near the intersection of Hillside Lane, bringing boulders and a fence with it but sparing the house in its path. Looking down canyon, the fence surrounding the swimming pool that was once the draw of the Rome Shady Brook Hotel is on the left. (Courtesy of the Silverado Public Library.)

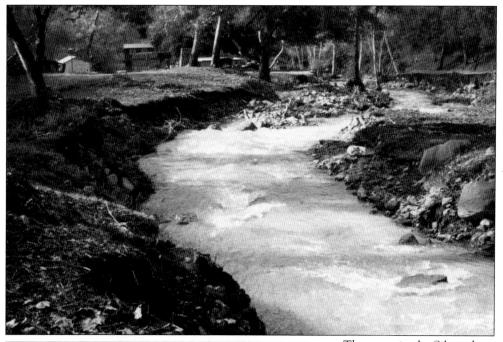

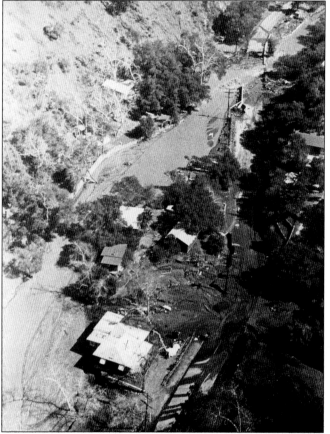

The water in the Silverado Creek began to recede shortly after the rain stopped, as seen here in this photograph looking down canyon just past the forest service gate at the end of Silverado Canyon Road in the Mine Tract neighborhood. (Courtesy of the Silverado Public Library.)

This aerial photograph illustrates the path of the creek as it overtakes a bridge and widens in the neighborhood of the Alpine Inn and Cactus Way. A portion of the now impassable Silverado Canyon Road can be seen in the top right of the photograph. (Courtesy of the Silverado Public Library.)

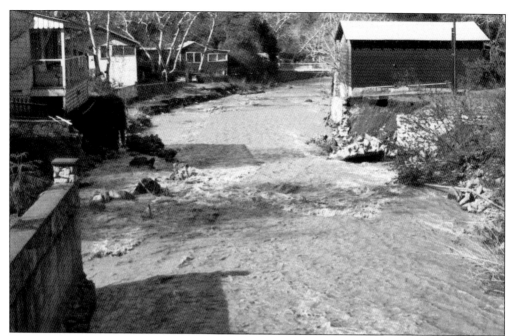

Houses along the Silverado Creek were most at risk of damage and destruction. The houses pictured here on the left have Water Way addresses and prime locations along the creek. Still flowing, but at a much slower and less dangerous pace, the creek spared most of the homes in this neighborhood of much damage. (Courtesy of the Silverado Public Library.)

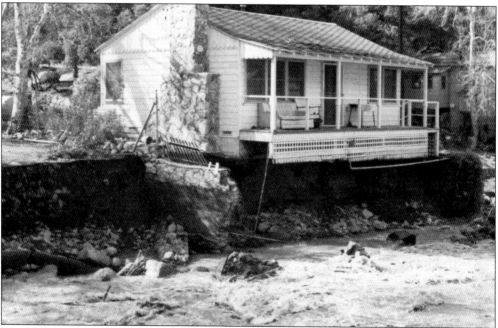

The Whipple residence, located on Water Way, narrowly escaped further damage during the 72-hour onslaught of rain. The now receding water leaves behind evidence of just how deep the creek was. The rising water at some points reached depths of 8 feet, and the creek widened in some areas to four times its normal width. (Courtesy of the Silverado Public Library.)

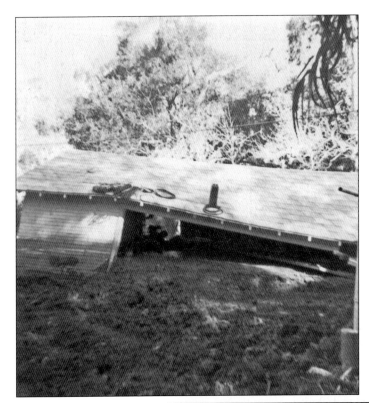

This house, located on Water Way and belonging to Charlie Stotts, was the victim of a mud slide that occurred while he was assisting with the retrieval of a propane tank about to fall into the creek. The hillside behind his home gave way, and mud entered through the garage and engulfed the structure. (Courtesy of the Silverado Public Library.)

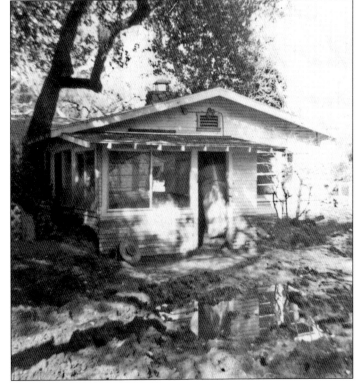

In this view of the home belonging to Charlie Stotts, the refrigerator can be seen in an unusual location. Pushed through the house by the strength of the mud flow, it ends up at a tilt near a side door. Mud surrounds the house, and a puddle reflects the damage that has been done. (Courtesy of the Silverado Public Library.)

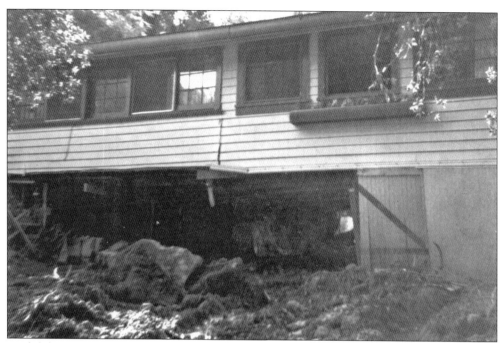

Mud slides proved to be responsible for a fair portion of the damage inflicted upon homes in the canyon. This home on Bond Way received its share of Mother Nature's fury. Invaded by rock and mud, the lower level sustained an enormous amount of damage, visible here in this photograph. (Courtesy of the Silverado Public Library.)

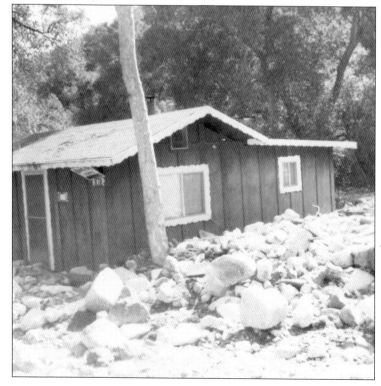

With the "For Sale by Owner" sign barely hanging on, this quaint canyon cottage was the victim of bad timing. Having been assaulted by a barrage of boulders, the cabin numbered 21 would need quite a bit of cleanup before a buyer was likely to be found. (Courtesy of the Silverado Public Library.)

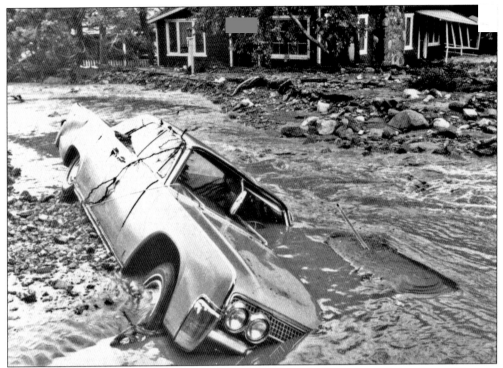

Automobiles were also casualties of the flood. This 1967 Lincoln Continental, belonging to Silverado resident Doc Smith, met its demise near the Shady Brook Grocery. Found semi-submerged in a depression in the road after the water receded, it would be deemed a total loss. (Courtesy of the Silverado Public Library.)

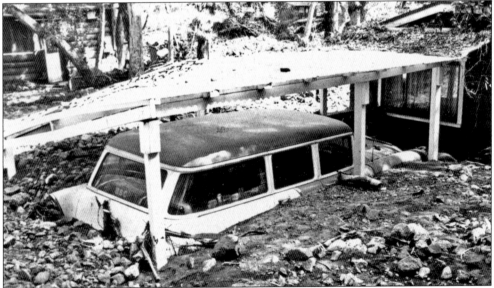

This mid-1950s Chevrolet station wagon, although safe from the pelting of rain, was not safe from the mud slide that enveloped it. Belonging to Shady Brook resident and Silverado volunteer firefighter John Sleppy, the well-traveled vehicle (as evidenced by the stickers in the window) would travel no more. (Courtesy of the Silverado Public Library.)

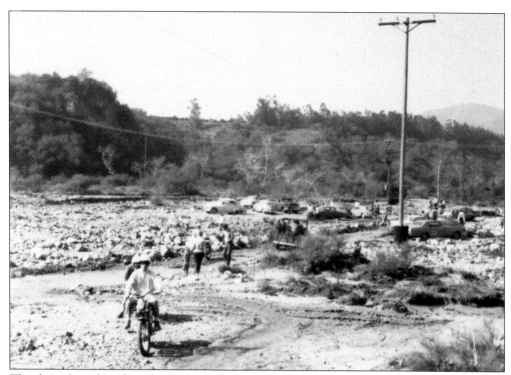

The skies cleared, and residents who had evacuated returned and sightseers arrived. Prevented from driving into the canyon by the mud-covered road, they parked their vehicles and walked or used bicycles in an attempt to gain access to their residences or to view the devastation and destruction. (Courtesy of the Silverado Public Library.)

A day or two after the rain stopped, an unidentified woman sits alone on the side of Silverado Canyon Road across from the church in the area formerly known as Carbondale and looks east into the canyon. The floodwaters have receded, and the extensive damage to the road is evident. (Courtesy of the Silverado Public Library.)

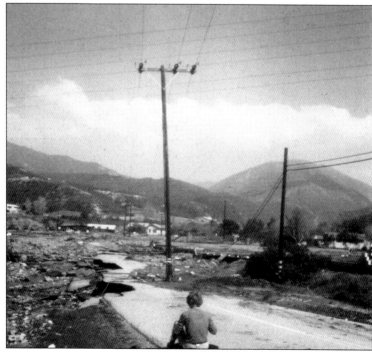

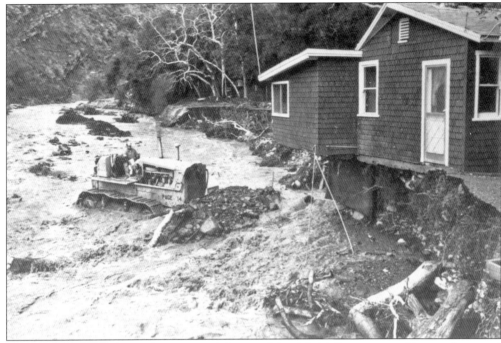

Cleanup began after the creek water receded to a safe level. Initially, canyon residents volunteered their time and equipment. The tractor seen here is used to move mud, dirt, and rocks underneath and alongside a house that sits along the creek to form a temporary foundation to help stabilize it and prevent it from falling. (Courtesy of the Silverado Public Library.)

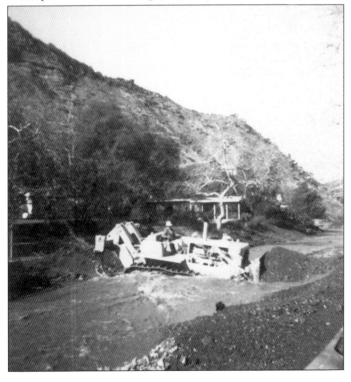

Houses situated along the creek were among those most damaged during the flood and were the most at risk of further damage should the heavy rain return. This earthmover was used to rid the creek of excess mud and debris, and to reestablish retaining walls. (Courtesy of the Silverado Public Library.)

At 10:00 a.m. on February 25, 1969, a landslide battered the Silverado Volunteer Fire Station, killing five people inside—two canyon residents and three volunteer firefighters. This aerial view depicts the path of destruction that began near the top of the hill and ended at the fire hall. (Courtesy of the Silverado Public Library.)

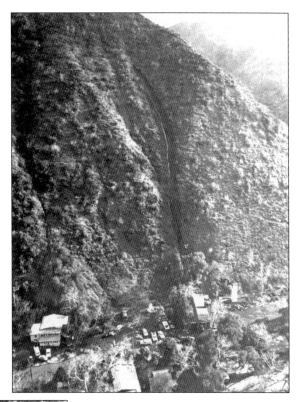

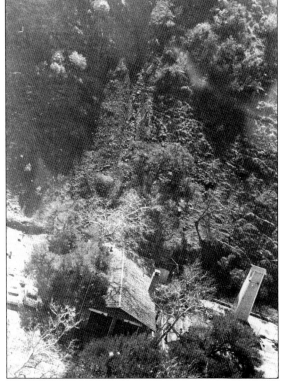

The Silverado Fire Station was used as an evacuation center during the nine-day storm. Approximately 35 frightened residents sought shelter and comfort among their friends and neighbors in the fire hall. This aerial view offers a closer look at the mud that brought death into the station and community. (Courtesy of the Silverado Public Library.)

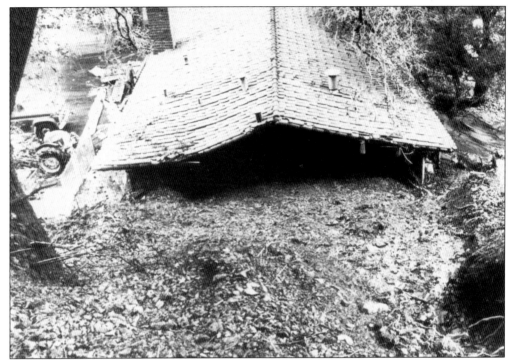

The back wall of the fire station was obliterated by the tons of mud that slammed into the building the morning of February 25, 1969. Killing five instantly and injuring many others, the force of the mud pushed the two fire engines parked inside the building out into the street. (Courtesy of the Silverado Public Library.)

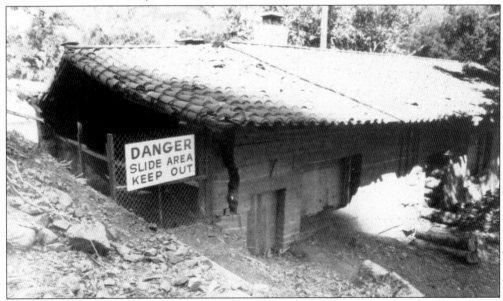

This sign posted at the badly damaged fire station warning potential trespassers of slide danger is a sad reminder of what took place here. The photograph, taken sometime after the recovery of the slide victims, depicts the now boarded up and abandoned fire station. It would eventually be partially demolished. (Courtesy of the Silverado Public Library.)

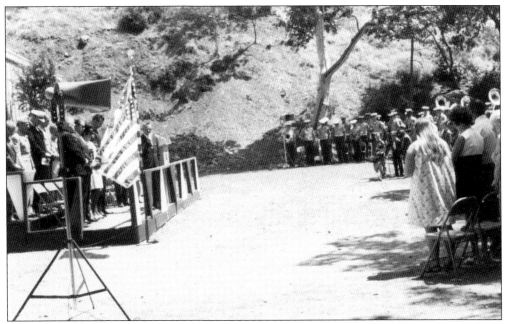

On July 18, 1970, a new fire station was dedicated. The newly constructed station was built on land adjacent to the original station. The dedication ceremony was open to canyon residents and was attended by local dignitaries. The local Boy Scout troop participated, and music was provided by a marching band. (Courtesy of the Silverado Firefighters Association.)

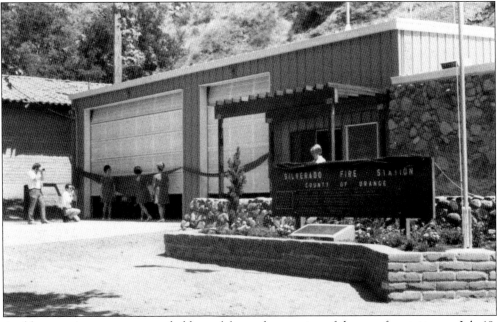

A ribbon-cutting ceremony was held to celebrate the opening of the new fire station on July 18, 1970. The new fire station incorporated rock from the Silverado Creek into its construction, and a flower bed was made using adobe brick from the original station. A wall of the now unused original station can be seen on the left side of this photograph. (Courtesy of the Silverado Firefighters Association.)

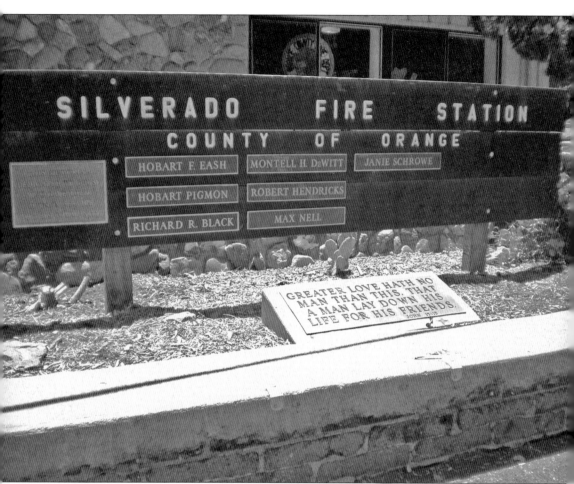

This memorial plaque stands in front of Silverado Fire Station 14 and honors those who perished in the station during the flood of 1969 and those who served on the volunteer fire department. The plaque was erected on July 18, 1970. Hobart F. Eash was a volunteer firefighter who died in 1954 of a heart attack while sitting on the back of a fire truck. Hobart Pigmon was a volunteer firefighter who died of a heart attack after responding to six emergencies in one day. Richard R. Black was a volunteer firefighter who perished in the mud slide. Montell "Monty" H. DeWitt, 40, married with sons and a resident of Hazel Bell Drive, was a volunteer firefighter who perished in the mud slide. Robert Hendricks, 16, was helping prepare sandbags for residents in need when he perished in the mud slide. Max Nell, a rock hunter and resident of Wildcat Canyon Road, sought shelter in the fire hall and perished during the mud slide. Janie Schrowe, married with three children, was a volunteer firefighter and perished during the mud slide. All were canyon residents. (Courtesy of the author's collection.)

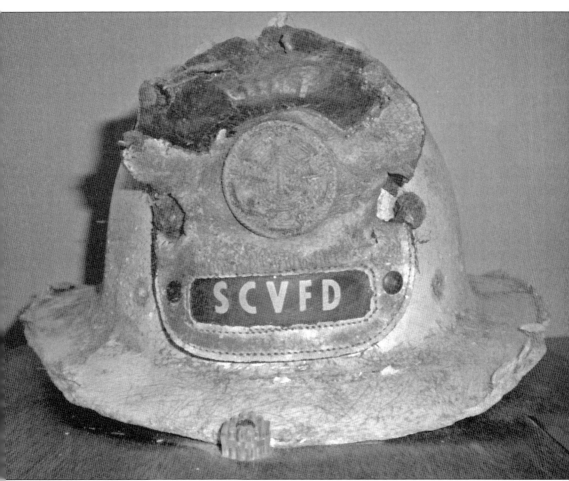

Silverado resident Keith Lynn was chief of the Silverado Fire Department during the flood of 1969. Called upon to relay a radio to a member of the California Department of Forestry who was stranded down canyon because of flooding without one, Chief Lynn donned his rain gear and left his structure helmet hanging on a hook inside the station. Accompanied by Don Higby, they arrived at the designated location, only to find that no one was there to receive the radio. It was during this time that a mud slide pummeled the fire station, killing five inside. The force of the mud pushed everything in its path out of the station, including two fire trucks and the helmet belonging to the chief. In May 1985, an employee of the Blue Diamond Sand and Gravel Company, located in Black Star Canyon, noticed something white and plastic in his haul. He uncovered the helmet of Chief Lynn. Returned to the Silverado Fire Station, it is now on display as a reminder of the powerful force of Mother Nature. (Courtesy of the author's collection.)

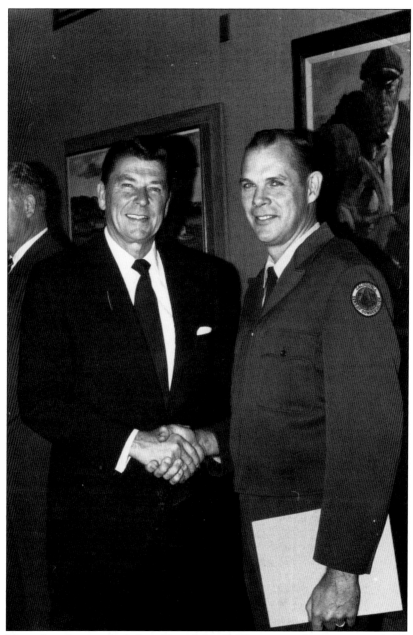

In 1971, Silverado volunteer firefighter Capt. John C. Sleppy, seen here, was awarded the Medal of Valor by then California governor Ronald Reagan. The Medal of Valor is the highest honor bestowed by the State of California. It honors employees who have performed an extraordinary act of heroism above and beyond the normal call of duty and have shown courage in the face of adversity. Sleppy was recognized for putting his life at risk to save the life of another during the mud slide that killed five in the Silverado Fire Station during the flood of 1969. Sleppy was inside the fire station when the mud slide occurred and had time to push a small child out a side door before he himself was buried under the debris. He managed to claw himself out of the rubble, escaping with a crushed pelvis, collarbone, and ribs, and continued to assist others in need until help arrived. (Courtesy of the Silverado Firefighters Association.)

Seven

ENJOYING THE CANYON

Silverado Canyon has attracted visitors since the late 1800s. Though they arrived first by horse-drawn carriages and buggies, such modes of transportation were eventually replaced by the automobile. The early visitors were usually residents of nearby towns such as Orange, Santa Ana, and Tustin. They came for a day, sometimes more, to escape the hectic city and to enjoy what nature had to offer. Hiking, hunting, and exploring the abandoned mining sites were common pastimes. Eventually, hunting was abolished, and visiting the abandoned mines was discouraged, so the Sunday drive became the most popular form of enjoyment. Adventurous types often hoped their drive would take them to the top of Santiago Peak. Some made it; others did not. In the 1920s, a visit with the superintendent of the Cleveland National Forest was often a reward for those who succeeded in reaching the summit of the peak. A drive through Silverado to the top of Santiago Peak is something that can still be enjoyed today, access permitting.

For residents, enjoying the canyon became a daily event. Sunny days brought the opportunity for children to enjoy an afternoon at a neighborhood plunge or participate in the Boy Scouts of America. Occasionally, Mother Nature brought snow, and normal activities were suspended in order to experience this rare event. In the 1940s, adults enjoyed Saturday nights at the local saloon, listening to a favorite musician and reenacting the days of the Gold Rush of 1849 with a local festival called "49er Days." To this day, the Silverado Country Fair, the first of which was held in November 1971, is an annual event that continues to attract both locals and visitors to Silverado Canyon.

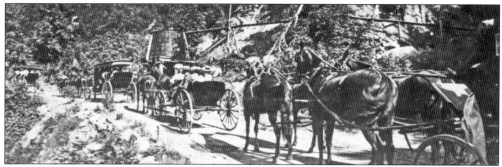

Taken in 1901, this photograph depicts a well-established, busy road that on this day allowed visitors access deep into Silverado Canyon. Two- and four-horse-drawn buggies transport well-dressed sightseers up into the canyon, past pines and a water tank into the area of the Blue Light Mine. (Courtesy of First American Corporation.)

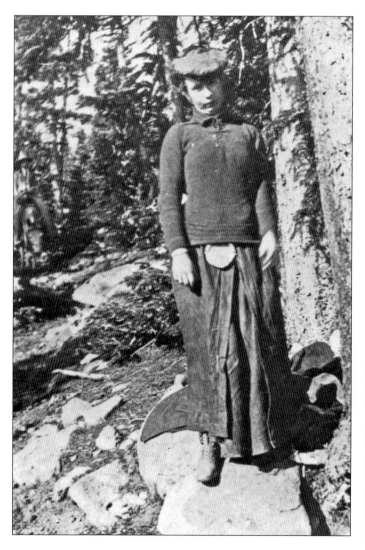

Jessie Flook Brakeman, a resident of Santa Ana, California, is seen here hiking in Silverado in 1891. Accompanied by a gentleman and his mule, she posed next to mature pine trees deep in Pine Canyon, an offshoot canyon in Silverado where the Blue Light Mine was located. (Courtesy of First American Corporation.)

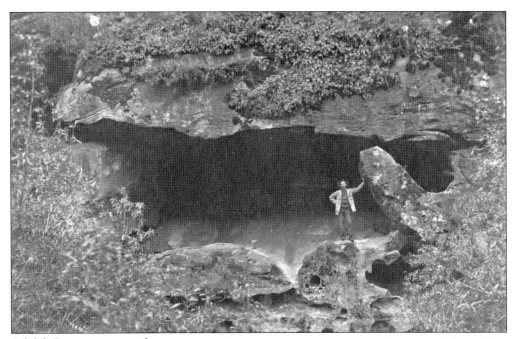

Adolph Dittmer, owner of Dittmer's Mission Pharmacy in Orange, California, enjoyed photography and often visited the canyon to explore and take photographs. He is seen here in Silverado in 1909, standing in the opening of a cave-like rock formation. (Courtesy of the Local History Collection, Orange Public Library, Orange, California.)

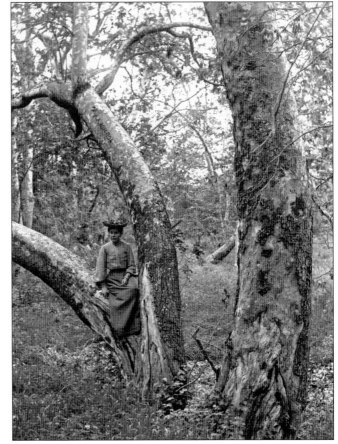

Louise Gunther Dittmer, wife of Adolph Dittmer, is seen here in 1906, posing on the branch of a beautiful, mature native sycamore tree in Silverado Canyon. A previous visitor has carved his initials and the date 1904 into the tree directly above her head. (Courtesy of the Local History Collection, Orange Public Library, Orange, California.)

This Silverado campsite, used by Adolph Dittmer in 1909, depicts a simple tent covering a camp bed made of branches and leaves. A kerosene lantern hangs inside the tent, along with a blanket, and a chair made of branches and tent cloth sits out front. (Courtesy of the Local History Collection, Orange Public Library, Orange, California.)

Situated among the sycamores and oaks, this c. 1900 photograph depicts the elaborate camping available to those spending time at the health resort known as Mason's Chateau. A tent cabin provides a dining area, and a chaise lounge and covered hammock allow guests and visitors to relax after "taking the waters." (Courtesy of First American Corporation.)

Ruby Alsbach is seen here in 1910, smiling broadly and saddled up on her trusty steed, appearing to enjoy an afternoon ride along Silverado Canyon Road. Spending an afternoon on horseback is an activity that continues to be enjoyed by Silverado equestrians today. (Courtesy of the Silverado Public Library.)

The Silverado Creek, seen here in this *c.* 1940 postcard image, is a tributary of the Santiago Creek. It meanders along, parallels, and crosses the Silverado Canyon Road. It was a sightseer's destination in itself. Bordered by sycamores, willows, and creek alders, the creek provides a natural habitat for a variety of amphibians and birds. (Courtesy of First American Corporation.)

This photograph, taken between 1913 and 1916, is a beautiful image of a group of four driving along the well-maintained Silverado Canyon Road. A popular pursuit, traveling the canyon road was time consuming and required a sense of adventure. The steepness of the canyon is evident and the threat of falling rock is constant, as the driver makes his way deeper and higher into the

canyon. Following the natural curvature of the hillside, the road parallels the Silverado Creek, which is clear and dazzling, and is bordered by alders and boulders. Hoof prints and tire tracks are visible in the road, evidence that others have come before. (Courtesy Anaheim Public Library.)

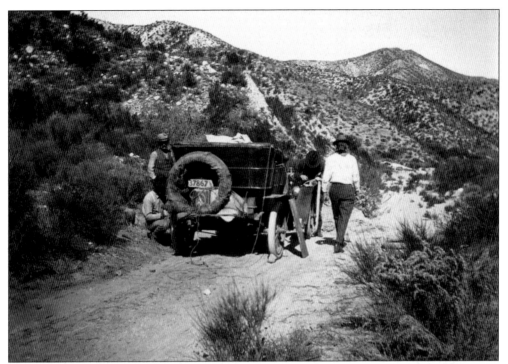

Perhaps attempting to reach Santiago Peak at the top of the canyon road, the four men seen here in this early-1900s photograph have encountered a roadblock or car trouble. Appearing well prepared to deal with the situation, the men work diligently to regain control of their vehicle and the road. (Courtesy of First American Corporation.)

The vista that presented itself to those who reached the upper canyon was spectacular. Low-lying clouds have crept into the canyon, visible in this photograph, taken between 1913 and 1916, and a chill is in the air, judging by the men and ladies bundled up in their hats and coats, who appear to be ready to head back down canyon. (Courtesy Anaheim Public Library.)

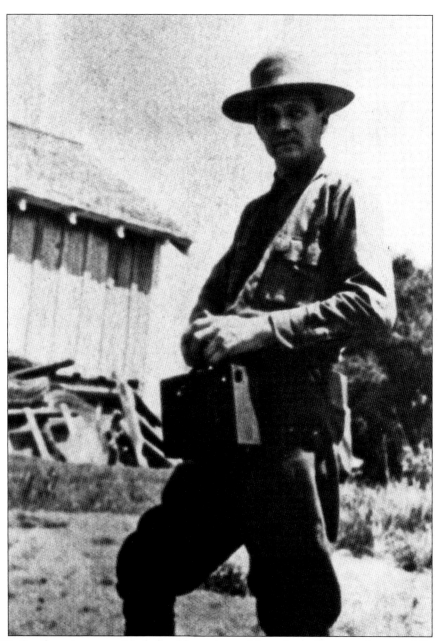

In 1921, Stephen Augustus Nash-Boulden, pictured here in uniform at the top of Santiago Peak, was superintendent of the Cleveland National Forest. The Cleveland National Forest was established in 1908 by then U.S. president Theodore Roosevelt to preserve and protect forest lands and included portions of the Santa Ana Mountains, of which Silverado Canyon belonged. At the top of the canyon is Santiago Peak, the highest mountain in Orange County, with an elevation of 5,691 feet. A forest service residence was installed on Santiago Peak, the second of such in the forest, and a ranger was posted there to monitor and patrol the area. A visit with the ranger was an added bonus to those who made it to the top. Visiting the peak was and still is popular with equestrians, hikers, and motorists, most of whom access it through Silverado Canyon. (Courtesy of First American Corporation.)

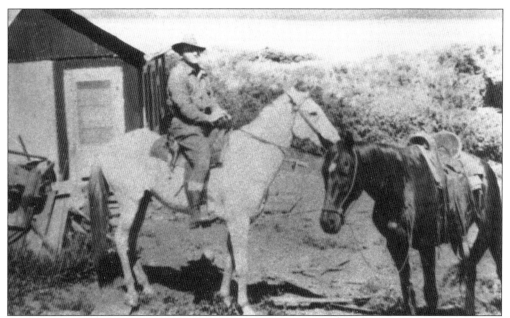

A lengthy horse ride through Silverado Canyon to the top of Santiago Peak was rewarded by the view, which on a clear day stretched from the surrounding mountaintops to Catalina Island. This visitor, seen here in 1920, has arrived at the top and is rewarded and photographed with such a view. (Courtesy of First American Corporation.)

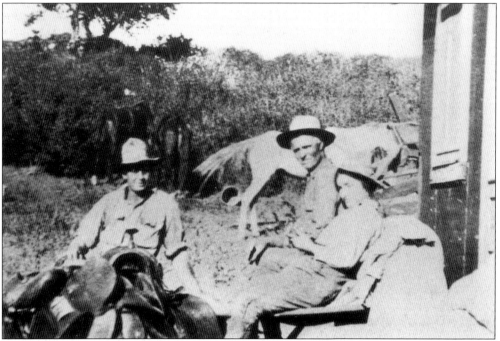

A visit with the ranger at the Santiago Peak ranger residence was a welcome respite for those making the all-day excursion by horse to the top. Pictured here in 1920 are two such visitors allowing themselves and their horses a well-deserved break while they visit with the ranger. (Courtesy of First American Corporation.)

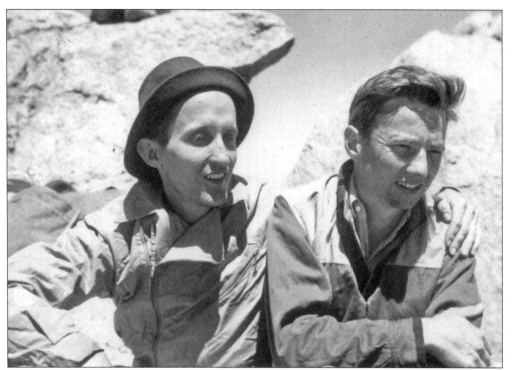

Well-respected climbers Dick Jones (left) and Glen Dawson share a moment of congratulations after reaching the top of Santiago Peak in 1941. Reaching the summit of the peak was a "must-do" for serious mountain climbers such as these. (Courtesy of Glen Dawson Collection, Sierra Club—Angeles Chapter Archives.)

This photograph, taken in February 1929 by climber Glen Dawson, shows Santiago Peak covered with snow. Viewed from the radio tower atop the peak, the cabin used by the forest superintendent is visible at the center of the image. Dawson noted "lots of snow and strange ice formations on the trees and bushes." (Courtesy of Glen Dawson Collection, Sierra Club—Angeles Chapter Archives.)

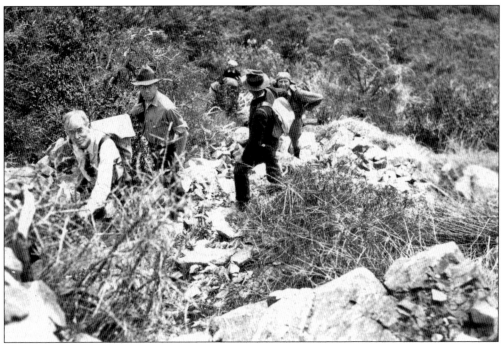

A Sierra Club party hikes through Silverado Canyon on its way to the top of Santiago Peak in this photograph taken on March 2, 1930. Navigating the trail and boulder-hopping through the native chaparral is required in order to reach the summit. (Courtesy of H. R. Sturdevant Collection, Sierra Club—Angeles Chapter Archives.)

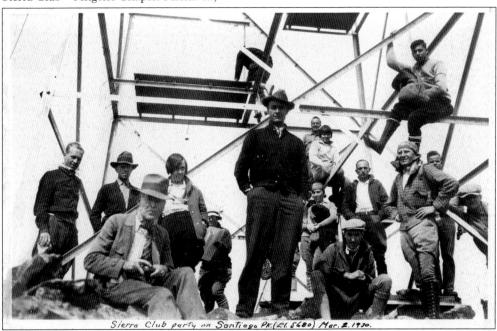

Having reached the summit, the Sierra Club party of March 2, 1930, assembles themselves on and around the radio tower atop Santiago Peak for this celebratory photograph. (Courtesy of H. R. Sturdevant Collection, Sierra Club—Angeles Chapter Archives.)

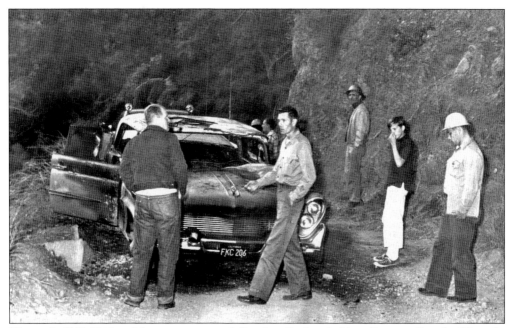

This early-1960s Friday night attempt to reach Santiago Peak ended in a distress call to the Silverado Fire Department and the arrival of forest service personnel. The vehicle in this photograph and its occupants would eventually be towed out of the canyon; others less fortunate would need the assistance of a helicopter. (Courtesy of the Silverado Firefighters Association.)

In 1933, the Civilian Conservation Corps group No. 255 constructed check dams along Santiago Creek for flood control. The dams, located beyond the forest gate at the end of Silverado Canyon Road, would become fishing spots and swimming pools for canyon residents in the 1970s. (Courtesy of the Silverado Public Library.)

January 15, 1932, brought snowfall to Silverado Canyon. This photograph depicts two young men posing on a bridge that spans the creek in the Mine Tract neighborhood, seemingly enjoying the 4 inches of snow that fell during the night. The reverse notes, "Everybody nearly went wild." (Courtesy of the Silverado Public Library.)

Three young men on the steps of the Romulus Club, located at the Rome Shady Brook Hotel, are seen in this c. 1945 photograph, bundled up and surrounded by an unusual amount of snow. At an elevation of 1,500 feet, snowfall of this amount was a rare event. (Courtesy of the Silverado Public Library.)

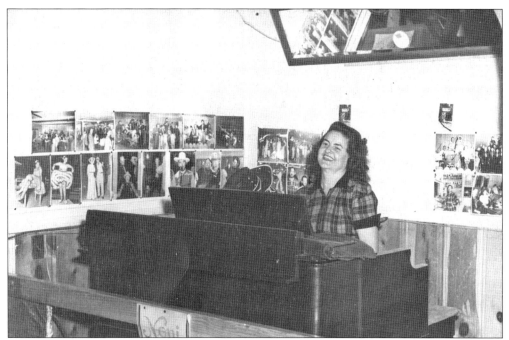

Saturday night customers of Tommy's Café came during the late 1940s to listen and dance to the music of featured entertainer Noni, who played a Hammond organ. She is seen here at her Hammond, smiling and playing for her fans. Tommy Beaulieu provided his patrons with a variety of entertainment, some of which can be seen in the photographs on the walls behind Noni. (Courtesy of the Silverado Public Library.)

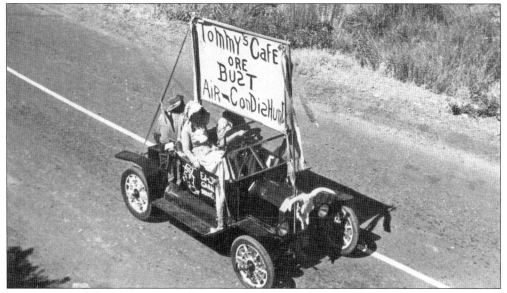

In 1949, Tommy Beaulieu organized an event to celebrate the centennial of the 1849 California Gold Rush, called "49er Days." Participants were encouraged to dress in costume and join in on reenactments of Gold Rush events. The folks seen here driving along Silverado Canyon Road have an obvious destination in mind, one that includes a modern convenience. (Courtesy of the Silverado Public Library.)

The stage is set inside the classroom at the Silverado Elementary School for the play that will be performed by the graduating class of 1940. A dramatic performance staged by the students and their teacher was an annual event held for parents and relatives of those enrolled at the school. (Courtesy of the Silverado Public Library.)

A hot summer afternoon often found canyon kids enjoying a dip in the plunge located on the property of the Wildcat Ranch, a privately owned residence and club. This 1950s-era photograph depicts two boys about to try their diving skills in the pool, which was graciously shared by the owner with canyon kids. (Courtesy of the Silverado Public Library.)

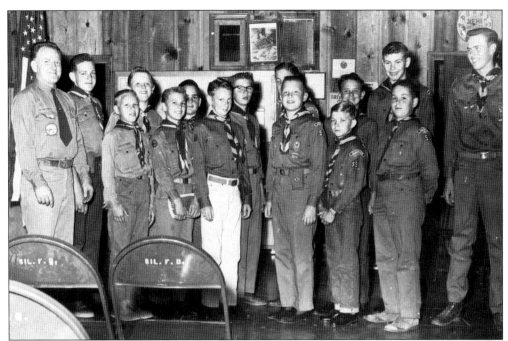

During the 1950s, Silverado Boy Scout Troop 59, headed by troop leader Bob Hobson (far left), held their once-weekly meetings at the Silverado Fire Station. The troop is pictured here in uniform at the conclusion of a meeting. Senior Scout Barry Olsen is seen at far right. (Courtesy of the Silverado Public Library.)

Boy Scout Troop 59 is seen here in this 1956 photograph smiling and making their way single file down Silverado Canyon Road. Along with their camping equipment and canteens, the leader of the pack carries an axe and proudly displays the American flag. (Courtesy of the Silverado Public Library.)

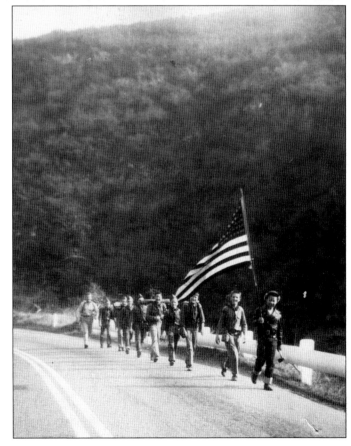

In 1977, at the request of canyon residents, the Orange County Transit District established a bus route from Orange to Silverado and back. The bus is seen here approaching the end of Silverado Canyon Road in the Mine Tract neighborhood. The service only lasted a few months. (Courtesy of the Silverado Public Library.)

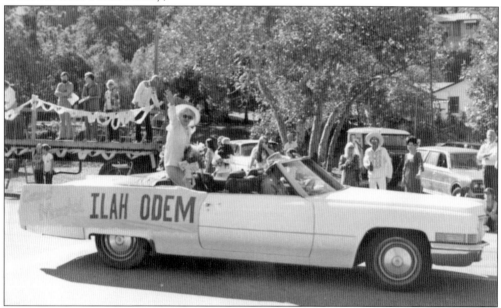

The Silverado Country Fair is an annual event that began in 1971 to showcase and offer for sale the arts and crafts of canyon residents. Held in the fall, the fair features a parade and celebrates a well-known and respected canyon resident as honorary grand marshal. Seen here in this 1976 photograph waving from the back of a convertible Cadillac is longtime resident and grand marshal Ilah Odem. (Courtesy of the Silverado Public Library.)

ACROSS AMERICA, PEOPLE ARE DISCOVERING SOMETHING WONDERFUL. *THEIR HERITAGE.*

Arcadia Publishing is the leading local history publisher in the United States. With more than 4,000 titles in print and hundreds of new titles released every year, Arcadia has extensive specialized experience chronicling the history of communities and celebrating America's hidden stories, bringing to life the people, places, and events from the past. To discover the history of other communities across the nation, please visit:

www.arcadiapublishing.com

Customized search tools allow you to find regional history books about the town where you grew up, the cities where your friends and family live, the town where your parents met, or even that retirement spot you've been dreaming about.

BIBLIOGRAPHY

Bell, Claudia, Janet Jacobs, and Diana Wamsley. *The Canyons Guide*. Orange, CA: Orange Unified School District, 1980.

DeCair, Ellen. *Harvey Asbury Shaw*. Fullerton, CA: Oral History Program, California State University, 1998.

Friis, Leo J. *The Charles W. Bowers Memorial Museum and Its Treasures*. Santa Ana, CA: Pioneer Press, 1967.

McClelland, Elsie. *Silverado Canyon Sketches, 1853–1953*. Los Angeles, CA: The Historical Society of Southern California, 1957.

Sleeper, Jim. *Bears to Briquets—A History of Irvine Park, 1897–1997*. Trabuco Canyon, CA: California Classics, 1987.

———. *Great Movies Shot in Orange County*. Trabuco Canyon, CA: California Classics, 1980.

———. *A Grizzly Introduction to the Santa Ana Mountains*. Trabuco Canyon, CA: California Classics, 1976.

Stephenson, Terry E. *The Shadows of Old Saddleback*. Santa Ana, CA: The Fine Arts Press, 1948.